Under Blue Cup

UNDER BLUE CUP

Rosalind E. Krauss

The MIT Press
Cambridge, Massachusetts
London, England

For information about special quantity discounts, please email special_sales@mitpress.mit.edu

This book was set in Garamond Premier Pro and Gotham by The MIT Press. Printed and bound in Spain.

Library of Congress Cataloging-in-Publication Data

Krauss, Rosalind E.
Under blue cup / Rosalind E. Krauss.
 p. cm.
Includes bibliographical references and index.
ISBN 978-0-262-01613-1 (hardcover : alk. paper) 1. Art—Psychology. 2. Memory (Philosophy) I. Title.
N71.K717 2011
701—dc22
 2011002071

10 9 8 7 6 5 4 3 2 1

for DENIS *and* PETER *and* DAVID *and* DAVID

contents

Acknowledgments

Incited by over a decade of disgust at the spectacle of meretricious art called installation, this book was made possible by fortuitous encounters with what I saw as its strong alternatives: a William Kentridge retrospective at the Barcelona Museum of Contemporary Art; a Christian Marclay show at the Barbican Art Gallery, London; a James Coleman exhibition at the Dia Foundation, New York; the Sophie Calle exhibition at the Centre Georges Pompidou, Paris; the full presentation of the Marcel Broodthaers film *L'analyse d'un tableau*, along with the accompanying slide piece *Bateau tableau*, at the Marian Goodman Gallery, Paris. To these museums and galleries I owe special gratitude.

The Walter Neurath Memorial Lecture in London, 1998, sponsored by Thames & Hudson, provided the occasion for a full-length development of my ideas on Marcel Broodthaers. Various seminars on medium specificity at Columbia University supplied the sounding board for my ideas, as they developed in concert with my splendid graduate students. The generous support for research made available by my post as University Professor at Columbia gave me the time and flexibility to undertake the challenge of writing this book. My colleagues at Columbia and at *October* magazine have been constant sources of encouragement and constructive critique.

My warmest thanks here to: Timothy Clark, Peter Sacks, Nikos Stangos, Andrew Brown, David Plante, David Frank, George Baker, Lauren Sedofksy, Teri Wehn-Damisch, Emily Apter, Mignon Nixon, Rosanna Warren, Karen Kennerly, Denis Hollier, and Yve-Alain Bois.

I could not have assembled the technical apparatus for publication were it not for the tireless contributions of my assistants Ryan Reineck and Elisabeth Tina Rivers. To Roger Conover, my constant support at the MIT Press, my utmost thanks for his belief.

Paris, 2010

one

WASHED AWAY

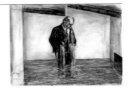

Late in 1999, my brain erupted. (1) It is called an aneurysm, but all the same it is an exploded artery launching a cataract of blood into the brain, disconnecting synapses and washing neurons away. Three neurosurgeries dammed the flow. Recovery came after in the rehab ward of New York's Hospital for Joint Diseases. In December, after this after, they advised that rehabilitation continue, both physical and cognitive. (2) Cognitive rehab consisted of strengthening short-term memory, as though I were an athlete being trained to leap over the puddles in my brain called *lesions*, a mysterious term from college but when I saw the CAT scans of my skull all too obvious.

In addition to elaborate memory games played on computer, the principal therapeutic tools for jumping were flash cards bearing either primitive drawings or disconnected bits of text. (3) Looking at the drawings I would see such random couples as a tennis pro paired with a zipper, or a football player

teamed with a yo-yo. After a 20-minute distraction I was expected to recall them, still side by side. Viewing the first example of the written kind, I encountered UNDER BLUE CUP, an inadvertent present to my pocketed memory and a lesson in how to remember these exact words, even in their hapless order.

Every morning during the months of recovery my husband had brought breakfast: coffee and a sweet roll, which he picked up at a shop on his way to the hospital. So "Cup" was now accounted for. Called A Kind of Blue, the coffee shop was owned and managed by a Croatian who came from Split, making "blue" another easy association. Some years earlier I had been to Split, as well as to its crystalline blue grotto on Biševo island. So I "saw" the grotto and was on the glass-bottomed boat once more.

Aneurysm — *The amnesia of the stain*

(1) It is called an aneurysm, but all the same it is an exploded artery launching a cataract of blood into the brain, disconnecting synapses and washing neurons away.

UNDER BLUE CUP, the legend on my initial flash card, triumphantly proved the first rule of mnemonic therapy: if you can remember "who" you are (never a certainty if you've been comatose), you have the necessary associative scaffold to teach yourself to remember a*nything*. It is curious to treat this narrative as if it were about myself, but I will soon disappear into its commitments to the art of the present.

UNDER BLUE CUP speaks to the project engaged by this book insofar as its subject is the concept of the aesthetic medium, which Jean-Luc Nancy is driven to call a *singular plural* in order to leverage the singular noun "Art" into the plurality of its aesthetic supports, each support bearing the name of a different *muse*. Jean-Luc announces his project when he titles his opening chapter "Why Are There Several Arts and Not Just One?"[1] I am approaching his question by my emphasis on the medium as a form of remembering, since the various artistic supports, each represented by its individual muse, serve as the scaffolding for a "who you are" in the collective memory of the practitioners of that particular genre—painting, sculpture, photography, film. It

speaks to the "who you are" of each muse, speaking also to the "who you are" of what I will show are the new genres that contemporary artists—during what I am calling the "post-medium condition"—feel an imperative to "invent." The invention of a medium will strike us as strange—since mediums develop over many centuries during which an entire guild uses their rules as a means of communication. An "invented" medium would seem to be merely idiomatic. But I will show here that there is no code (aesthetic or linguistic) that is not open to interpretation or careful reading.[2] A medium is the articulation of such a code.

Brain — *The medium is the memory*

The flood I'd sustained created memory gaps that I had to be trained to bridge. Thus the aneurysm thrust forgetting into my experience as a possibility I'd never imagined. It forwarded the urgency of remembering, sustained by the identity of a "who you are."

Chessboard — *The medium is the support*

It was the medieval system of the guilds that presided over the arts as so many separate crafts: carvers in charge of stone or wood; casters responsible for bronze, either statues or doors; painters at work on stained glass wooden panel or plaster wall; weavers on grand ceremonial tapestries. Separate skills were also maintained by the Schools of Fine Arts begun in France under Colbert. *Ateliers* divided painters from sculptors as students learned by copying the virtuosity of their masters. The rules transmitted by the guilds concerned the preparation of various supports for the artisan's work of representation— the craft of sanding and waxing the wooden panel, after which came the careful spreading on of bole so that its terra-cotta layer would cushion the gold leaf's fragile skin. The two-dimensional support that defines painting as a medium required its artisans to conquer the drumhead flatness of wall or panel as it obstructed their efforts to resonate an opening behind it, a little fictive

3

space on which so many figurative presences could be placed like actors human or supernatural on a stage.

Ever since the Renaissance, the stage had been the concern of what Alberti had termed the *legitimate construction*, his name for the geometry of perspective that progressively torqued the paving stones of palace or cathedral into the staccato of black squares challenged by white. This checkered paving made the chessboard not only the foundation for the actors in the pictures' narrative but also the means of piercing the drumhead of the painting's flatness, puncturing the opacity of its resistant matter. For painters, the memory of *"who" you are* means recalling a system of making that from the Renaissance forward exploited perspective and its transections as a rich source of meaning. Painting's memory nests two supports within each other, since if perspective is the support of imaging, the chessboard, as Hubert Damisch has shown us, is the support of perspective.[3]

In the twentieth century, abstract art jettisoned the earlier access to a meaning staked on the space "behind" the canvas drumhead. Painters opposed this by using the drumhead itself as their theme.

The cubists organized the drumhead as an upright chessboard which they schematized as graph or grid. By means of the gridded surface, meaning could flow from an act of referral to the uniqueness of painting's support, as it required each artist to define the difference between the drumhead and the painter's marks by "pointing" to the drumhead itself. Nietzsche meant that kind of pointing when he called painting's specific resistance to visual penetration its "luminous concreteness," as Tim Clark gratefully quotes from *The Birth of Tragedy*.[4]

This pointing-to-itself came to be called *specificity* and entered the discourse of modernist criticism as *medium specificity*.

Such acts of pointing were understood as a form of self-definition for which artists found a multitude of strategies over centuries of practice. Since pointing was meant to direct attention to the medium as support for the representation, we can speak of it as recursively representing that support, or, as I will term this, "figuring it forth." Modernist theory held this self-definition to be a *recursive* structure—a structure some of the elements of which will produce the rules that generate the structure itself, the way the rules of modulating color (called "atmospheric perspective") both open and close painting's "luminous concreteness." The rules of cubist practice produced the *grid*,

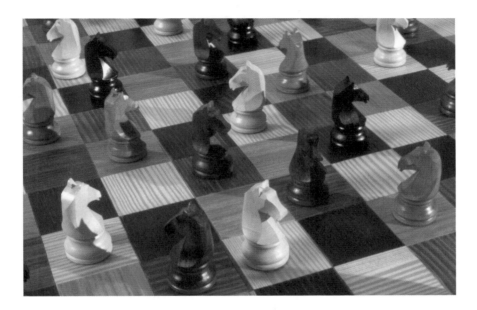

Figure 1.1
Gabriel Orozco, *Horses Running Endlessly*, 1995.
Wood, 3⅜ × 34½ × 34½ in. Courtesy Marian
Goodman Gallery, New York.

which pointed three ways at once: first to the flatness of the canvas the way graph paper creates a net everywhere taut and seamless; second to the edges of this flatness with each tessera miming the picture's frame; third to the microfiber of the canvas, so as to "figure forth" the very tissue of the canvas weave. The idea of rules as the vehicle of specificity drives a wedge between the way medium specificity is being used in these pages and the way it functioned in the most prestigious theorization of its relation to modernism, at the hands of Clement Greenberg. For Greenberg, the nature of a medium was established by a brute positivism: painting is flat; sculpture is three-dimensional and freestanding like an object; drawing is the cursive tracing of edges and boundaries as opposed to painting's access to color and penumbra. Greenberg's specificity is empirically tied to a physical substance.[5] The specificity onto which I want *Under Blue Cup* to open is focused, rather, on the rules of the guilds. This is what will distinguish its idea of specificity from Clement Greenberg's. The positivism of Greenberg's designations (as in his dogma that painting's specificity is to be found in the flatness of its support) has troubled certain critics and philosophers, its note sounded by Cavell's complaint that this reductive reflex has brought about "the fate of modernist art generally—that its awareness and responsibility for the physical basis of its art compel it at once to assert and deny the control of its art by that basis."[6] Elsewhere Cavell qualifies this denial, with its feckless abdication of aesthetic responsibility—a "dire fate." His own invocation of the rules of a medium he calls an *automatism*, the way the rules for marrying the voices of a fugue or moving through the tonality of the development section of a sonata are alone in allowing for the spontaneity of improvisation which keeps classical Western music, as well as its jazz, alive.[7]

Figure 1.2
Pablo Picasso, *Standing Female Nude*, 1910.
Charcoal on paper, 19 × 12⅜ in. (48.3 × 31.4 cm).
The Metropolitan Museum of Art, New York,
Alfred Stieglitz Collection, 1949 (49.70.34).
© 2010 Estate of Pablo Picasso/Artists Rights Society
(ARS), New York. Image © The Metropolitan
Museum of Art/Art Resource, NY.

Greenberg's position is also attacked by critics who might be thought to be his greatest advocates, as when Michael Fried holds Greenberg's notion of sculptural specificity responsible for what he dismisses as the "literalism" of the minimalist art he rejects: "Part of my argument with Greenberg's reductionist, essentialist reading of the development of modernist art," he says, "was precisely this case history in Minimalism of what happened if one thought in those terms" (as when the minimalists literalize Greenberg's notion of sculptural specificity as the brute distinction between painting's flatness and sculpture's physical bulk).[8] In his further critique of Greenberg, Fried made *shape* into a "medium" of abstract painting. Frank Stella was his example, when his *Polygon Series* seemed to gather shape together on the canvas so as to "invent" what Fried called a new medium for abstraction. One of representation's pictorial conventions is that since contour produces a figure leveraged away from its background, such a depicted *shape* will not coincide with the painting's "literal shape"—the bounding edge it shares with any ordinary object (table chair or packing case)—a sharing minimalism welcomed as canceling Western illusionism and its separation of art from objects at large. Against this brute reduction, and contrary to Greenberg, Fried saw *shape*, not flatness, as a way of declaring the specificity of painting.[9]

Figure 1.3
Ellsworth Kelly, *Colors for a Large Wall*, 1951. Oil
on canvas, sixty-four panels, 7 ft. 10½ in. × 7 ft.
10½ in. (240 × 240 cm). The Museum of Modern
Art, New York, Gift of the artist. © Ellsworth
Kelly. Digital image © The Museum of Modern Art/
Licensed by SCALA/Art Resource, NY.

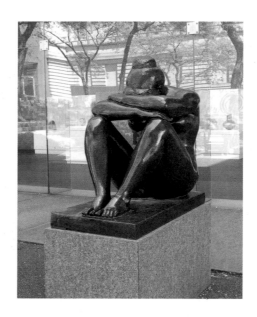

Figure 1.4
Aristide Maillol, *Night*, 1939. Bronze, skin
renewed by cold chiseling, 41½ × 43½ × 24 in.
Carnegie Museum of Art, Pittsburgh; Gift of
the A. W. Mellon Educational and Charitable
Trust, Accession number 60.49. © 2010 Artists
Rights Society (ARS), New York/ADAGP, Paris.

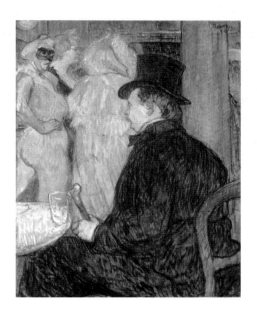

Figure 1.5
Henri de Toulouse-Lautrec, *Maxime Dethomas*,
1896. Oil on cardboard, 67.5 × 50.9 cm (26⁹⁄₁₆ ×
20⅞ in.); framed 99.1 × 87.0 cm (39 × 34¼ in.).
Courtesy National Gallery of Art, Washington;
Chester Dale Collection.

Figure 1.6
Morris Louis, *Saraband*, 1959. Acrylic resin on
canvas, 8 ft. 5⅛ in. × 12 ft. 5 in. (256.9 × 378.5 cm).
Solomon R. Guggenheim Museum, New York,
64.1685.

Figure 1.7
Richard Artschwager, *Table and Chair*, 1963–1964.
Melamine laminate and wood, 75.5 × 132.0 × 95.2 cm.
© 2010 Richard Artschwager/Artists Rights Society
(ARS), New York. Image © Tate, London 2010.

Figure 1.8
Robert Morris, *Untitled (L-Beams)*, 1965. Stainless
steel, 243.8 × 243.8 × 60.9 cm (8 ft. × 8 ft. × 24 in.).
Collection of Whitney Museum of American Art,
New York, Gift of Howard and Jean Lipman. ©
2010 Robert Morris/Artists Rights Society (ARS),
New York.

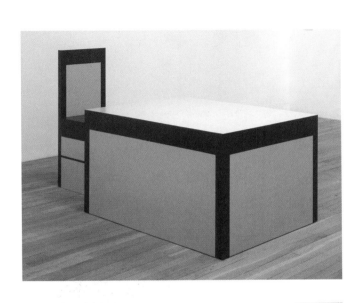

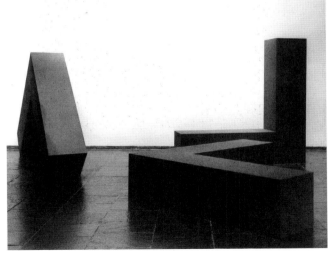

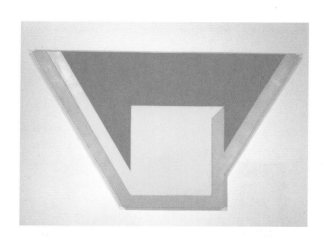

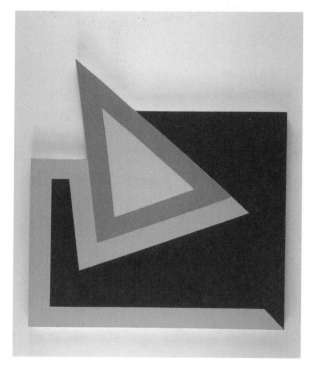

Discursive unity — *The a priori of the medium*

Michel Foucault invokes what he calls the "barbarous term" *historical a priori* in order to determine how a variety of authors can occupy the single "discursive unity" that gathers them, historically, into "the same conceptual field," all of them led to address the "same object." In postwar America, *medium* was such an object, made "historical" in Foucault's terms by its "form of dispersion in time, a mode of succession, of stability, and of reactivation."[10]

Greenberg was perhaps the first to stabilize *medium* as the locus of discursive unity, his essay "Modernist Painting" fixing the a priori of the discourse around the poetic trope of *synecdoche* which Foucault would elsewhere call "analogy and succession" (the very trope Foucault saw Marx expounding around the a priori of labor, and Darwin developing around the a priori of life).[11] For Greenberg himself, the analogical thread of painting was the physical support made recursive by means of a self-criticism, which drove the ways of acknowledging that support, in its very flatness, successively forward. In this sense medium can be seen as what Foucault elsewhere calls an *epistemē*, a coherent language (based on the poetic tropes, such as metaphor, metonymy, synecdoche, that Giambattista Vico had called "poetic knowledge").[12] This, Foucault argues, is a figurative language all authors within a given epoch will

Figure 1.9
Frank Stella, *Union III*, from the *Irregular Polygon Series*, 1966. Fluorescent alkyd and epoxy on canvas, 103¾ × 173¾ in. (263.5 × 441.3 cm). The Museum of Contemporary Art, Los Angeles, Gift of Robert A. Rowan. © 2010 Frank Stella / Artists Rights Society (ARS), New York.

Figure 1.10
Frank Stella, *Tuftonboro IV*, from the *Irregular Polygon Series*, 1966. Fluorescent alkyd and epoxy paint on canvas, 99 × 109 in. Collection of the artist. Photo: Steven Sloman; licensed by Art Resource, NY. © 2010 Frank Stella / Artists Rights Society (ARS), New York.

unconsciously speak at the same time. Foucault's discursive object is made historical by being both stabilized and reactivated. We have here seen the "reactivation" of the medium as discursive unity through the successive objections to Greenberg's modernism. The discursive unity joined Fried's voice to Cavell's supplication that modernist practice escape its "dire fate," since, as Cavell says, "modernist art . . . rediscovers the fact that its existence as an art is not physically assured."[13]

To put at a distance the term *medium*, with its merely "physical" assurance, Cavell introduced *automatism* to refer to the rules by which practitioners of a given discipline gain the freedom to improvise, by moving, for example, through the chordal progressions open to the tempered scale of Western music, as when Bach could *improvise* fugues on five or six voices, or the pianist can improvise the cadenza called for at the end of a sonata.

Foucault's historical a priori reopens the issue of the medium, its discursive space allowing reactivation and succession. In joining my own voice to this discursive space with its critique of a reductive logic, I am substituting "technical support" for the traditional idea of a physical medium—*medium* itself a "support" for the work of art—such as the canvas's underpinning for oil paint, or the metal armature's scaffold for plaster or clay. As opposed to these traditional foundations, "technical supports" are generally borrowed from available mass-cultural forms, like animated films, automobiles, investigative journalism, or movies—hence "technical" replaces the "artisanal" materials of the guilds; in the same way "support" neutralizes the individual names of the *muses*. The need for these substitutions arose from the "discursive unity" of postmodernism, which decreed the very idea of a medium obsolete.

Expansion — *The medium is the binary*

(3) Looking at the drawings I would see such random couples as a tennis pro paired with a zipper, or a football player teamed with a yo-yo.

But what if a medium were not a material support—oil on canvas, tempera on wooden panel, pigment on wet plaster—the materials worked by the guilds?

What if it were the very foundation of representation, the way painting's chessboard supports the actors on its stage? What if it were a logic rather than a form of matter?

Structural linguistics discovers meaning as the sum of two opposing terms, which it calls *binaries* and Roland Barthes renames "paradigm."[14] The opposition of male to female could be said to generate the paradigm of /gender/; while the opposition of front to back projects the paradigm of /depth/, and high versus low gives us /verticality/.

Since the paradigm is a logical support, it can substitute itself for a physical substance in founding the rules of a medium. Constituting a unified field, the medium's paradigm might be considered the foundation of all the possible variations open to a physical substance—pigment supported in turn by canvas, wooden panel, leaded glass, or plastered wall. Later in this argument I will explore the paradigm of /medium/ itself, as a binary of memory versus forgetting. Sometimes the duty of reducing a medium to the binary of a paradigm is provoked by such a wild diversity of the production within what are commonly thought as the possibilities of a given material substance that, in order to recover the fundamentals of the paradigm, its binaries must be unearthed. In the 1970s, sculpture suffered this violent dispersal. Its variations took the form of earthworks, of architectural interventions (sometimes called "site-specific" and sometimes the "institutional critique" of temporary incursions within museums meant to "expose" their repressive functions), and of the human body in performance, dance, or video installation. Criticism took this profusion at face value, some critics robotically understanding it as a collective rejection of the medium of sculpture, while others meditated on the paradigm of /sculpture/ trying to discover the unified field—or specific medium—to which, of necessity, all this diversity must have belonged. The unity of the paradigm, structuralism teaches us, can be sustained through many permutations of the original binary, as it is expanded into a logically related "group." "Sculpture in the Expanded Field," which I wrote in 1978, is this kind of meditation, structurally reducing /sculpture/ to the underlying paradigm that serves as its binary or logic so I could build its expanded "group" as a unified field.[15] My thought was that sculpture's most exemplary instance is the monument (think Stonehenge; think dolmens), whose paradigm I set out to discover. Monuments are everywhere—on city squares or gardens, in

cemeteries, churches, and palaces. My move was to generalize the /monument/ to the binary of a representation anchored to its site by a pedestal that both elevates the sculptural likeness above the ground and anchors it to that place, as if "imaging forth" its very situation. As it doubles back to absorb this place, what the monument represents is the significance of the exact location for the inhabitants of the palace, the celebrants within the cathedral, the buried in the cemetery, the citizens of the urban space. Its representation could thus be called "recursive." It is what Kant would call a *condition of possibility*, a conceptual foundation.

The logic reconstitutes the impossibly dispersed medium of /sculpture/, showing how it both inhabits and depends on a unified field bound together by the binary, despite the variegated grounds of human bodies, broken mirrors, photographic field trips, flashes of lightning.[16] The logic distances medium from matter, resisting the Greenbergian "reduction." The post-medium condition of our age resembles the radical dispersal of '70s sculpture, as installation art, now updated as relational aesthetics—both of them variants of institutional critique—opens contemporary practice to a profusion of forms joined by conceptual art's contempt for specificity. But the medium's unified field can nonetheless be charted. As I've said, it exfoliates outward from the binary of *memory* opposed to *forgetting*.

Forgetting — *Technical supports*

The car, the slide tape, the animated film are not traditional supports for artistic practice the way oil on canvas, line on paper, or plaster on armatures are. They are "technical supports," bred in reaction to postmodernist disdain, itself empowered by the exhaustion artists felt, in the 1970s, with both the traditional mediums and modernism's insistence on *specificity*. For postmodernism, the cubist grid's abstraction was forgotten, to be replaced by mounds of hay, its sobriety supplanted by the muscular figures of fascism's neoclassicism; while the revival of the Renaissance bronze declared the purist geometries of modernist sculpture dead and gone.[17]

Within this situation that we could call a dilemma but was really a crisis, the avant-garde had no choice but to identify itself with a search for

fresh supports, ones untainted by the stigma of an exhausted tradition. Postmodernism drove the avant-garde to turn at first to technology as the most virulent possible alternative to the natural materials of traditional mediums. Video was such a technology. But the avant-garde resorted to other supports as well, themselves drawn the way video is from available mass-cultural forms. These new means for making art need a new name in order to hold them distinct from the traditional forms; hence my term "technical support." The "technical support" is open-ended, possible to elaborate into the rules of Cavell's *automatism*. His adoption of *automatism* as a more generalized version of *medium* is another symptom of the postmodernist retreat from the specific medium. Cavell is ambivalent, however, about completely abandoning the term *medium* even with its unwanted associations: "this is why," he writes, "although I am trying to free the idea of a medium from its confinement in referring to the physical bases of various arts, I go on using the same word to name those bases as well as to characterize modes of achievement within the arts."[18] I find *automatism* tempting, with its implication of rules, even while I share Cavell's ambivalence. It is only the word *medium* that conjures the recursive nature of the successful work of art. The artists who discover the conventions of a new technical support can be said to be "inventing" a medium, the way Fried saw Stella "inventing" *shape* as a new medium. In insisting on the absolute necessity of prolonging the specific medium as the ground for aesthetic coherence, *Under Blue Cup* will explore eight examples: Ed Ruscha's use of the automobile; William Kentridge's elaboration of animation by means of painstaking erasure; James Coleman's adaptation of the slide tape, a primitive version of PowerPoint; Christian Marclay's exploitation of the synchronous sound track of commercial films; Bruce Nauman's adoption of the architectural trope of the *promenade*; Sophie Calle's parody of investigative journalism; Marcel Broodthaers's welcome to the historical coherence of the art book (what André Malraux had called *the museum without walls*); and Harun Farocki's foregrounding of the video editing bench. Each of these supports allows the artist to discover its "rules," which will in turn become the basis for that recursive self-evidence of a medium's specificity. If such artists are "inventing" their medium, they are resisting contemporary art's forgetting of how the medium undergirds the very possibilities of art. If *Under Blue Cup* is about one idea, this is what it is about.

Genius — *Three things*

At the time of the postmodernist crisis of the 1970s, three things happened to make it irrefutable that the specific medium had fallen onto the trash heap of history. The first was postminimalism and its rejection of the minimalist literal object—the boxes the slabs the fluorescent tubes—as so many things to be bought and sold. In 1973 Lucy Lippard called this collective dismissal "the dematerialization of the art object," pointing to ephemeral works such as pencil marks on walls as the fragile alternative. The second thing was conceptual art and its declaration that the object was now supplanted by the dictionary definition of *art* as such—the idea *art* transcending the dispersal of separate mediums; thus, art-as-such dispenses with Jean-Luc Nancy's conception of the muses as "several and not just one." The third was Duchamp's eclipse of Picasso as the most important artist of the century. Duchamp had invented the readymade, or the objects he merely bought, signed, and then installed inside museums. Conceptual art saw this intervention as the naked definition of the object's aesthetic status and made Duchamp its god. As art became "idea," the medium vanished; it washed away. The *three things* opened our age onto what must be called the post-medium condition, rhyming with Walter Benjamin's reference to "the age of mechanical reproduction." But by the mid '70s some artists began to reject the three things. To do this, each appropriated a technical support and used it to "invent" a medium.

As I said, the technical support is not an idea, it is a rule. It runs on the track of Cavell's *automatism* the way, in traveling the road, the car demands refills of gasoline or places to park, each space alike just as the cars twin one another. The car doubles as the Hollywood dolly, allowing the traveling camera to shoot *Every Building on the Sunset Strip* from a moving van, if that's what it wants.

Ed Ruscha took the car as a means of spurning the three things. It is modern, not a return to historical objects. Its rules are not its definition in the sense of "idea" but its *automatism*, which rhymes with *auto*. The car is the support for Ruscha's medium; Roland Barthes would call its specificity its "genius."[19] It is there in the world but it is not a readymade that Ruscha signs and says there, that's my work of art. As a technical support the car stops Duchamp dead in his tracks.

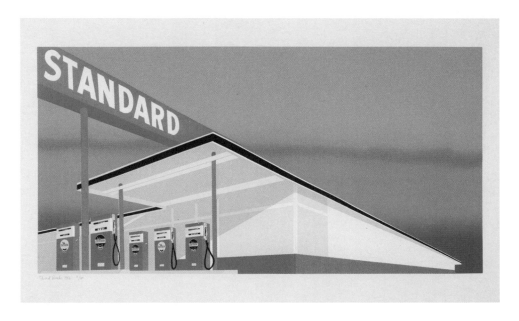

Figure 1.11
Ed Ruscha, *Standard Station*, 1966. Screenprint,
printed in color, composition 19½ × 36¹⁵⁄₁₆ in.
The Museum of Modern Art, New York, John
B. Turner Fund (1386.1968). Digital Image © The
Museum of Modern Art/Licensed by SCALA/Art
Resource, NY.

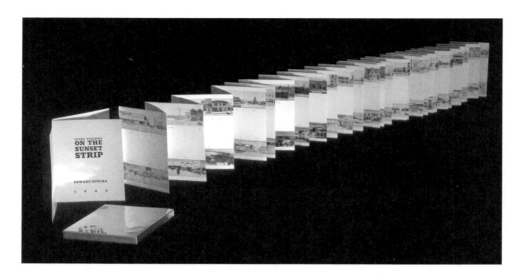

Figure 1.12
Ed Ruscha, *Every Building on the Sunset Strip*,
1966. Accordion fold; two continuous motorized
photos, 7¹⁄₁₆ × 5½ × ⁹⁄₁₆ in., weight 3¾ oz. Boxed
in mylar-covered case. First edition: 1000 copies,
1966. Second edition: 500 copies, 1969. Third
edition: 5000 copies, 1971. © Ed Ruscha. Courtesy
Gagosian Gallery.

Figure 1.13
Ed Ruscha, *Twentysix Gasoline Stations*, 1962. 48
pages, 26 illustrations, 7¹⁄₁₆ × 5½ × ⁷⁄₃₂ in.
Glassine dust jacket; sewn binding. First edition:
400 (numbered) copies, 1963. Second edition:
500 copies, 1967. Third edition: 3000 copies, 1969.
© Ed Ruscha. Courtesy Gagosian Gallery.

TWENTYSIX

GASOLINE

STATIONS

Husserl — *The* différance *of the difference*

A fourth thing must be added to the eclipse of the "who-you-are" of a specific medium as the recursive form of self-definition. This was the rise of poststructuralism in the 1970s (as deconstruction mounted a radical critique of the structuralist binary). For Jacques Derrida, the "who you are" of a fixed identity mandates an experience of the self-presence required by just that auto-definition of modernism, its "pointing to" or "figuring forth" its own ground understood as the *self* it coincides with. Roland Barthes calls the "who you are" of a medium such as photography its *noeme*.[20] As Derrida's concept of *différance* took hold in America, the "who you are" of a stable identity was dismissed as indefensible, naive.[21] Deconstruction renamed *identity* a specious "self-presence" which pictures consciousness as a mental state closely in contact with itself, like an inner voice that murmurs our thoughts directly to our brains.[22] Speech, bridging outside and inside, is for Husserl an immediate, instantaneous coincidence of self-with-self, a "now" that outlaws any gap or caesura between the voice (logos) and consciousness. Insisting on just such a gap as the inescapable violation of this law of immediacy, Derrida called it "spacing" so as to invoke the linguist's theory of the written sign and to privilege writing over logos. Spacing, he said, sets up the way the sign cannot open onto the "who" of self-presence as a simultaneity of mind grasping the meaning offered to it by logos. The sign, he insisted, is a form of re-mark, with the second syllable of a pair of sounds (as in pa-pa and ma-ma) both differing from the first, as an outside to the first, and coming after it. This coming after (which defers meaning) reaches back to transform the first, changing it from the random babble of the infant into a signifier—the coming-after of the second a requirement of meaning that nonetheless cleaves the signified in two, splitting presence from itself as well, with its outside to the "now" of self-presence inexorably opening the self to difference. Writing rifts the presence of self-to-self into the disjunctive fragments of repeated parts that can never coincide with "themselves." For deconstruction there can be no *cogito ergo sum*.

To analyze Husserl's dismissal of the intermediary of the sign, Derrida writes: "The self-presence of experience must be produced in the present taken as a now. And this is just what Husserl says: if 'mental acts' do not have to

be informed about themselves through the intermediary of indications, it is because they are 'lived by us in the same instant' (*im selben Augenblick*). The present of self-presence would be as indivisible as the *blink of an eye*." Derrida points to the conclusion Husserl draws from this insistence on the "blink" of the "now": "Since lived experience is immediately self-present in the mode of certitude and absolute necessity, the manifestation of the self to the self through the delegation of representation of an indicative sign is impossible because it is superfluous."[23] Derrida expressed deconstruction's marriage of *deferral* and *differing* in a manner only perceptible in writing. He invented the neologism *différance—ence* indistinguishable from *ance* in the logos of spoken French. If structuralism's /binary/ had opened a term to its logic of oppositional differences as it strove to locate the *noeme* or "who" of a given practice—what Barthes had called its "genius"—deconstruction's war on self-presence was a radical critique of structuralism's certainties.

The synchrony of these four things, from conceptual art to deconstruction, opens the *historical a priori* of the post-medium condition as a "discursive unity." The four things provide the conditions of possibility of the paradigm shift in which modernism's specific medium is superseded by the implacable deconstructive challenge to a "who you are."

Could one ask if *Under Blue Cup* is a fifth thing? By tracking the substitutes for the traditional idea of the medium that contemporary artists are forced to "invent," don't the notions of *technical support* or the *binary logic* inadvertently conspire with "the four things," sapping the strength of tradition? In the 1970s artists practicing the individual traditions of painting and sculpture found these already undermined, their seeming aridity the breeding ground for the adventures of postmodernism. *Under Blue Cup*'s argument is not inadvertent; it urges us to understand that those strategies allow a newly wrought means of pointing to "who you are"—in Barthes's terms a new *genius* for the viewer to experience—or what, following Nietzsche's "luminous concreteness" of the planar support, we will be calling a new *pool's edge* to push off against. The inventors of technical supports as a new form of recursivity are challenging the post-medium insistence about the end of the space specific to art's autonomy, what conceptual art dismissed as the white cube; instead they rely on the resistance of its walls to penetration, the way the sides of a pool provide the swimmer with a kicking post against which to propel himself in a new direction.

Imaging forth — *The medium is the frame*

William Kentridge's little animated film *Ubu Tells the Truth* is both an allegory of postmodernism's attack on the specific medium and a way of resisting it. Père Ubu, adapted from Alfred Jarry's play *Ubu roi*, is the obese protagonist of this morality sketch, a character Kentridge himself describes as "the emblematic 20th-century man of power, cruelty, self-pity and social blindness."[24] The "truth" Ubu tells is addressed to the South African Truth and Reconciliation Commission, which grants amnesty to the vigilantes who had committed atrocities under apartheid. In the film, Ubu's crimes show him brandishing a sword that he not only directs at Africans but strikes at the very medium of film, represented as a large eyeball protruding into the darkened frame in a recall of both the slashed orb of Dalí's *Un chien andalou* and the aperture-encaged eye that Dziga Vertov's *Man with a Movie Camera* (the most medium-specific of all films in the history of cinema) uses to emblematize the camera's lens.

Ubu, Kentridge's villainous hero, thus profanes the medium while savaging his country's citizens. Kentridge's own resistance to the desecration of the medium sometimes resorts to figuring forth his filmic support. At times the darkened edges of the image make it look like a film frame. At others, these squares create the illusion in which, seen as the background to a series of prisoners' bodies falling helplessly down the screen, the succession of window frames they traverse "images forth" a celluloid strip rising behind the cascade of men as though to respool into the gate of the projector, through which we are, even now, viewing the film.

Gripped by the elegance of this enactment of modernist self-reference, the viewer of this allegory is led to wonder, "Who, then, is Ubu?"

From the perspective of *Under Blue Cup*, my answer (though not necessarily Kentridge's) would be one of the two enemies of the individual muse: Marcel Duchamp on the one hand, on the other Joseph Kosuth, author of "Art after Philosophy," the opening manifesto of conceptual art. Duchamp's punctilious withdrawal from the world of art makes him an unlikely Ubu, but Kosuth's ambition to lead an attack on modernist practice suggests a more plausible parallel.

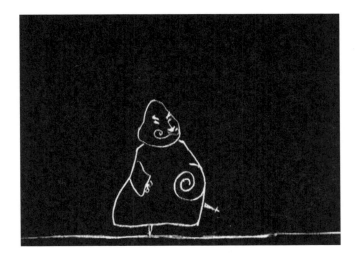

Figures 1.14, 1.15
William Kentridge, video stills from *Ubu Tells
the Truth*, 1997. Courtesy of the artist and Marian
Goodman Gallery, New York/Paris.

Figures 1.16, 1.17, 1.18
William Kentridge, video stills from *Ubu Tells the Truth*, 1997. Courtesy of the artist and Marian Goodman Gallery, New York/Paris.

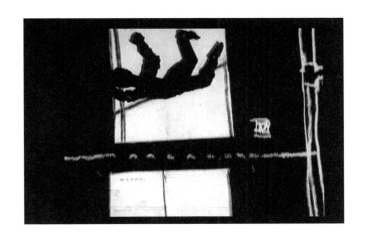

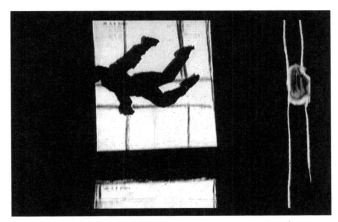

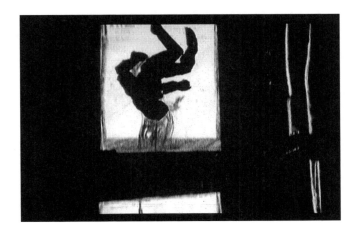

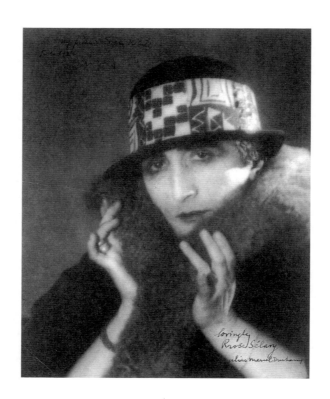

loringly
Rrose Sélavy
alias Marcel Duchamp

Arguing that art truly begins at the point where philosophy ends, Kosuth points to the modern transformation of metaphysics into analytic (or language) philosophy as the symptom of transcendental philosophy's current demise (at the hand of analytic philosophers such as Ludwig Wittgenstein, A. J. Ayer, or Willard Quine). For Kosuth, contemporary art begins in a parallel to philosophy's death, with art, like philosophy, substituting language for its formerly mute appeal to vision. Such a substitution, he argues, began with the work of Duchamp, whose practice of the readymade—implicitly demanding from its viewer the verbal assertion "This is art"—likewise transforms art from object into statement.[25] In Kosuth's terms,

> Being an artist now means to question the nature of art. If one is questioning the nature of painting, one cannot be questioning the nature of art. If an artist accepts painting (or sculpture) he is accepting the tradition that goes with it. That's because if you make paintings you are already accepting (not questioning) the nature of art.[26]

Joust — *Art after the medium*

In prompting the question "what makes this thing (urinal, bottle rack, coat hanger, curry comb) art?," the readymade has thus shifted from the specific to the general.[27] In a quest for the basis of art-as-a-whole, it has ditched the medium along with the recursive structures that make it possible to state "who you are."

The success of conceptualism has brought with it its peculiar amnesia, as the mnemonic condition of the medium is washed away in its own aneurystic flood. The flood overwhelms everything. Against it, Kentridge chooses to figure forth the ground specific to his technical support, as when he turns the windows of the Johannesburg Police Headquarters into luminous rectangles that double as film frames, or enacts parts of the filmic apparatus with the falling prisoners. Ignoring conceptualism, Kentridge joins a small band of guerrillas doing battle against the current post-medium practice. That condition, characterized by the term installation art, is engaged in the constant rehearsal of Duchamp's inaugural gesture—the entry of ordinary components into the context of some form of aesthetic institution, whether museum, gallery, or art fair—in order to ask, once again, the general question—"What makes this *art*?"—rather than the specific one of the medium.[28]

Knights — *The guerrillas of the medium*

Under Blue Cup is an act of remembering, an insistent "who you are": a crusade to think back beyond the onset of conceptual art with its Ubuesque fanaticism; a shrug of the shoulders at deconstruction's dismissal of the "self." Its concern is those very few artists who have had the courage to resist the aneurystic purge of the visual, a purge meant to bury the practice of specific mediums under the opprobrium of a mindless moralizing against the grounds of art itself: the aesthetic object which it abjures as mere commodity, and the specificity of the medium which it shuns as inadequately philosophical. *Under Blue Cup* will call these defenders of specificity the "knights" of the medium.

How I stopped worrying and Learned to love the Bomb — *The Messengers of the media*

Medium and *media* are what the French would call "false friends"—French look-alikes for English words that are strictly *not* synonymous. *Déception* is an example; in French it has nothing to do with trickery or *deceit* but, rather, with *disappointment.*

Blue movie

Television settled into American life and American homes in the 1950s. I remember strolling at dusk along the rows of terrace houses in my neighborhood, where I saw a spattering of blue glows emanating from the upper-floor windows like submarine auras announcing the place of the bedrooms and the presence of the somnolent bodies next to their TVs. The aquatic radiance seemed to semaphore an intense privacy only betrayed to outsiders by its telltale halo.

Media theorist Marshall McLuhan restricted this idea of privacy to the media channel of the printed book, opened by Gutenberg's invention of movable type: books held in the reader's hands were only to be experienced in isolation. Television, broadcast as it was to many viewers at once, supposedly annulled this privacy, fusing its simultaneous reception into what McLuhan called a "global village."

The aphorism is the message

"Gutenberg galaxy," "global village"—the media theorist writes in aphorisms, just like the telegraphic form of media transmission itself. Accordingly, *Under Blue Cup* theorizes the *deception* of media through its own rhetoric of aphoristic fragments.

Full fathom five thy father lies

Bill Viola, video artist of the 1980s, exploits the blue glow's urban message of the recumbent subjects in his work *The Sleepers*, with its television monitors submerged in bins of water, the familiar aquamarine halos rising from their rims to betray the video presence of pillowed heads sleeping at peace in their watery graves.

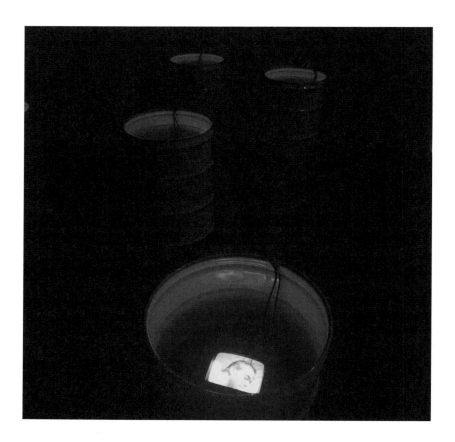

Figure 1.21
Bill Viola, *The Sleepers*, 1992. Video installation,
12 × 20 × 25 ft (3.7 × 6.1 × 7.6 m): seven channels
of black-and-white video images on seven small
monitors, each submerged at the bottom of a fifty-
five-gallon white metal barrel filled with water;
large dark room. Photo by Louis Lussier.

Dreaming in video

Another work, *The Sleep of Reason*, cites one of Goya's most famous pages from his *Disasters of War*—fully titled *The Sleep of Reason Produces Monsters*. Goya's print hunches the sleeper on a wooden box as, over his head, a rainbow of grotesques plays in the midnight air.

Viola's *Sleep of Reason* follows a similar strategy to *The Sleepers*, marrying bedroom with the customary TV on the bedside table, its monitor picturing a recumbent head. Like the blue glows in the upper-story windows of my neighborhood walks, Viola's monitor is synchronized with thunderclaps and flashes of images—understood to be fragments of the sleeper's dream.

Viola's ambition is to explore the phenomenological reach of video, marrying its artistic practice to television's broadcast reaching directly from one consciousness to another.

Video carries television's narratives of its actors' intentions, dilemmas, conflicts, and the way these elicit their viewers' immediate sympathy; phenomenologist Maurice Merleau-Ponty writes, "to look at an object is to inhabit it, and from this habitation to grasp all things in terms of the aspect which they present to it."[29] Radio and film were the mass-cultural media that promoted a desire for the synchrony of sound and image provided by television, a synchrony video art inherited and exploited.

Cassandras of the medium

Under Blue Cup has relied on the historical importance of the aesthetic medium as the specific *support* for a given practice—artisanal, academic, industrial. With the advent of modernism, this insistence on *specific* mediums—as the recursive source of the object's meaning—became absolute. *Absolute* then became *obsolete* at the hands of media's most famous theoreticians, Marshall McLuhan and Friedrich Kittler; for the former, media are modern communications vehicles, while they are technical storage, translation, and transmission systems for the latter.[30]

Lost in translation

Translation is the task of the computer's optical-fiber network as it reduces all formerly separate data flows into one standardized *digital series of numbers*, such that any medium can be translated into any other. Kittler is a Cassandra of the medium when he reports: "A total connection of all media on a digital

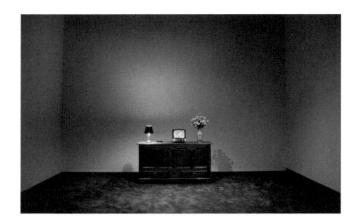

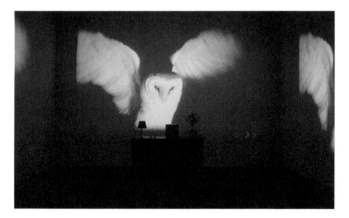

Figure 1.22
Bill Viola, *The Sleep of Reason*, 1988. Video/sound
installation, 14 × 27 × 31 ft (4.3 × 8.2 × 9.4 m):
color video images projected on three walls of a
carpeted room; wooden chest with black-and-white
video image on small monitor, vase with white
artificial roses, table and lamp with black shade,
digital clock; monitor, room lights, and projections
controlled by random timer; amplified stereo
sound and one channel of audio from monitor.
Photo by Richard Stoner. Courtesy of the Carnegie
Museum of Art.

base erases the notion of the medium itself. Instead of hooking up technologies to people, absolute knowledge can run as an endless loop."[31] Along with the three things and deconstruction, media make a fifth.

Bombs bursting in air

Kittler's focus on the optical-fiber network basic to the computer interface acknowledges the role of the military as the heartbeat of media. The Pentagon's rush to immunize national communications against the high-intensity electromagnetic pulse of nuclear attack drove the military's development of the optico-electric channel that supports the cyberface. Both McLuhan and Kittler follow Walter Benjamin's assertion that the system of aesthetic production of any given age will control "the manner in which human sense perception is organized."[32]

McLuhan's invocation of the *galaxy* for the perception organized by the advent of movable type and the spread of the printed book shares Benjamin's totalizing use of "Age" in the title of his "Work of Art in the Age of Mechanical Reproduction": "To pry an object from its shell . . . is the mark of a perception whose 'sense of the universal quality of things' has increased to such a degree that it extracts it even from a unique object by means of reproduction."[33]

The universal quality of things

Kittler's emphasis on media as storage files declares the invention of cinema an "epochal change" that permits the recording and reproduction of the temporal flow of acoustic and optical data. This, he says, "changed the state of reality more than lithography and photography," since with it "ears and eyes have become autonomous." To this same end Kittler quotes Nietzsche hunched over his typewriter and saying, "Our writing tools are also working on our thoughts."[34]

Supply side

Another parallel with this analysis of technological effects on the human sensorium echoes Benjamin's dictum, "One of the foremost tasks of art has always been the creation of a demand which could be fully satisfied only later."[35] Kittler rewrites this in relation to the rise of printed books as the widely used nineteenth-century storage technology, which "forms the material basis for new, hermeneutically programmed reading techniques that enable readers to experience an 'inner movie.'" No sooner capable of it, Kittler holds, than a desire arises

"in these readers to invent, or at least immediately select, the new cinematographic technology that provides images for real."[36] Here we encounter the concept of "cultural revolution" that Fredric Jameson recoded from its context in Cold War China into this technological incitement of desire.[37]

Jameson's idea of "cultural revolution" follows Lévi-Strauss's explanation of the "structural analysis of myth" in which myth is seen as a way of suspending unbearable contradictions in the real by projecting them into the imaginary space of narrative. Turning to Joseph Conrad's novel *Lord Jim*, Jameson points to the irresolvable conflict between "high" literature and the new mass-cultural production of adventure tales, sea narratives, and popular yarns, to argue that the autonomous universe of Jim's seabound ship, the *Patna*, demands the rise of modernism to suspend these contradictions within the aesthetic purity of an impressionist chromatic version of *l'art pour l'art*.

If modernist autonomy is the place of resolution to irresolvable contradictions in the real, modernism's insistence on the separation of individual mediums is canceled by the echo chambers of both McLuhan's and Kittler's definitions of media. Both of them see new media as the development that supersedes and combines older media. For McLuhan this translates into his aphorism "The medium is the message," by which he means that one medium's content is always other media: film and radio constitute the content of television; records and tapes are the content of radio; silent films and audiotape that of cinema; text, telephone, and telegram that of the semi-media monopoly of the postal system.

Winchester 45

Kittler's fiber-optical example turns his focus to the military and what he calls "a series of strategic escalations," from which it follows that television is a by-product of radar technology; early film coincides with the history of automatic weapons technology; the development of early telegraphy was the result of a military need for the quick transmission of commands and intelligence; and the computer arose from the need to encrypt and decode military intelligence and to compute missile trajectories.[38]

For all media theory these nested Chinese boxes cancel the very idea of a separation between mediums. Kittler's cancellation turns on the numerical streams into which all information—visual, auditory, oral—will be

38

quantified. Once this digitization happens, any medium can be translated into any other. A total media link on a digital base will erase the very concept of medium.

Supply and demand

What was the "cultural revolution" addressed by the arrival of video?

The advent of video art so pervasive in the 1970s and '80s brought with it a sharpened focus on a kind of telepathic perceptual experience, the viewer invited to pierce the opacity of the human skull transmitted before him so as to see or hear the "thoughts" of the other—making consciousness itself a form of broadcast.[39] Such piercing had been the task of the traditional picture's "high" ideal of the chessboard's illusionistic penetration of the material surface of the image plane. The novel's mass-cultural and "low" form of narrative opened the private interior of its characters to the reader's perception, exploiting the intimacy of Emma Bovary's *style indirecte libre*. Television then performed the cultural-revolutionary suspension of high and low with its sense of effortless transmission direct to the viewer's brain.

Disasters of war

Radio addressed the autonomy of the ear, not the centrality of the eye so important to painting and film. Bill Viola's *Reasons for Knocking at an Empty House* (1982) anticipates this radiophonic address to the viewer's inner ear as the visitor sits before a video monitor wearing a headset. A wall text alerts him to the nineteenth-century story of Phineas Gage who had suffered an iron spike driven through his skull in a freak railway accident. Gage's head faces the viewer/listener, who "hears" the sounds interior to Gage's consciousness, as he swallows, breathes, and clears his throat.

Abodes for the gaze

Viola's *Room for St. John of the Cross* (1983) is a *mise en abîme*: the little television set on St. John's desk, which we spy through the window of his study, is a miniature of the room itself, a tiny representation of the screen of his imagination, with the walls around the cabin swept by giant visions of mountaintops and driven snow. Merleau-Ponty has prepared us for this miracle of video—the media equivalent of phenomenology:

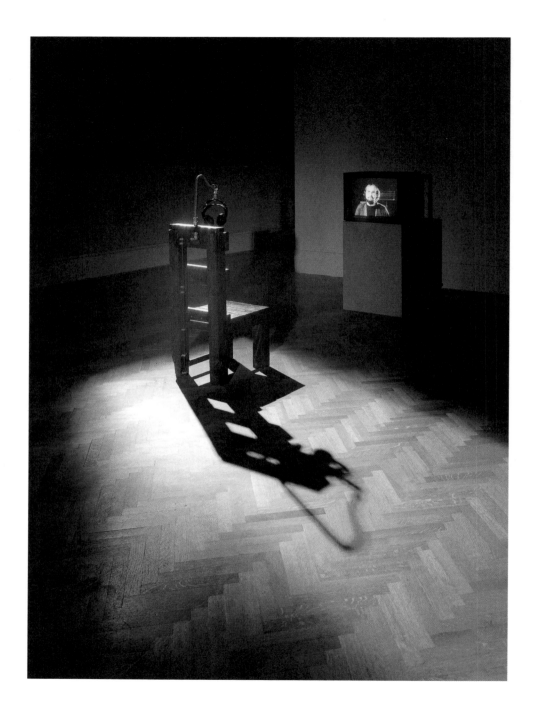

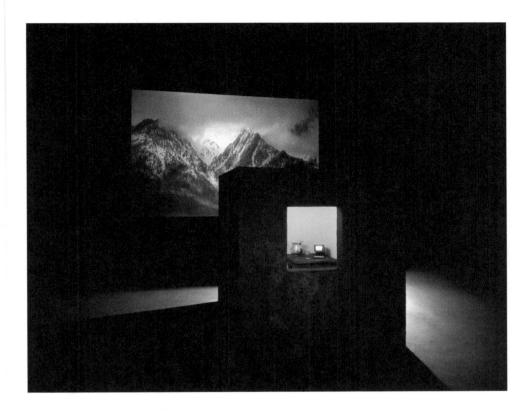

Figure 1.23
Bill Viola, *Reasons for Knocking at an Empty House*,
1982. Video/sound installation, 12 × 18 × 25 ft
(3.7 × 5.5 × 7.7 m): color video image on 25-inch
monitor; wooden chair with amplified sound in
attached stereo headphones; second amplified
stereo sound source in room on two loudspeakers.
Photo by Kira Perov.

Figure 1.24
Bill Viola, *Room for St. John of the Cross*, 1983.
Video/sound installation, 14 × 24 × 30 ft
(4.3 × 7.3 × 9.1 m): in a large dark room, and black
cubicle with window, the illuminated interior
containing peat moss on the floor, a wooden table,
glass with water, metal pitcher with water, color
video image on 3.7-inch monitor, one-channel
mono sound; black-and-white video projection
on wall screen; amplified stereo sound.

To see is to enter a universe of beings which *display themselves*, and they would not do this if they could not be hidden behind each other or behind me. In other words: to look at an object is to inhabit it, and from this habitation to grasp all things in terms of the aspect which they present to it. But insofar as I see those things too, they remain abodes open to my gaze, and being potentially lodged in them, I already perceive from various angles the central object of my present vision. Thus every object is the mirror of all others.[40]

Zero degree — *The avant-garde of the medium*

Roland Barthes wrote *Writing Degree Zero* in 1953 as the manifesto for a new avant-garde of authors who had substituted the nonliterary forms of journalism and conversation for what Barthes disdained as the *belles-lettres* of classical prose. On the horizon of *Under Blue Cup*, the zero degree of what Barthes also called *white* or *bleached writing* can be seen as a new "technical support" that allows the author to forget the classical tradition even while remembering the writerly force of his very medium.[41] In this zero-degree argument, it is speech that displaces literature. Conversation happens in the present, not in the written narrative signaled by the special tense of the historical past (the preterite in French) and the exclusive use of the third person.[42] But this avant-garde's *forgetting* is only provisional; it is intruded upon by *remembrance*. Here Barthes writes:

> There is a History of Writing. . . . At the very moment when general History proposes—or imposes—a new problematics of the literary language, writing still remains full of the recollection of previous usage, for language is never innocent; words have a second-order memory which mysteriously persists in the midst of new meanings. Writing is precisely this *compromise between freedom and remembrance*, it is this freedom which remembers and is free only in the gesture of choice, but is no longer so within duration: It is not granted to the writer to choose his mode of writing from a kind of non-temporal store of literary forms. . . . A stubborn

after-image, which comes from all the previous modes of writing and even from the past of my own, drowns the sound of my present words.[43]

As "technical support," then, *white writing* invents a new medium for the author to invest.

Barthes had elsewhere explained the zero degree as a variant on the structural-linguistic concept of the Neutral term, as in Vigo Brøndal's explanation of how the Neutral's third position disrupts the phonological binary.[44] Speech demands that sounds be distinct: the implosive form of a D negated by the explosive sound of a T to insure the binary D/T. This important difference can be neutralized, however, as when the D at the end of single-syllable words in German is pronounced T (as in *Hund [hunt]* and *Bund [bunt]*) or in English, when the T follows an s (as in *still*, pronounced *sdill*). The zero degree of speech neutralizes what Barthes calls the coercion of literature's language of power (that is, the class assumption that *its* [bourgeois] values— of clarity and unity—are universal). The zero's neutralization can thus be graphed as non-forgetting plus non-remembrance, exactly the status of the technical support's invention of a medium.

Bleached language, freed from literature, seeks the present tense of conversation or the diction of the everyday. Thus Barthes's avant-garde includes Camus's style, grounded in journalistic prose, as an example of this "zero degree," or for another instance, writing as the kind of "conversation" to be found in Raymond Queneau, where a building superintendent enters into a long Heideggerian ramble about the *Dasein* of a lump of butter: "The lump of butter isn't everything it isn't; it isn't everywhere it isn't, it stops everything else being where it is, it hasn't always been and won't always be ekcetera, ekcetera. So that we can say that this lump of butter is up to its eyes in an infinity of nonbeing. . . . It's as simple as Hello. What is, is what isn't; but it's what is that isn't. The point is that nonbeing isn't on one side and being on the other. There's nonbeing and that's all, seeing that being isn't."[45]

Camera Lucida was not a manifesto for yet another avant-garde but rather Barthes's attempt to define the specificity of photography—its *genius* or its *noeme*, as he put it. Finding this in the indexical form of the photograph with its insistence that *that has been*, Barthes called it "Death in person."[46] Photography's capture of the human image achieves a zero degree when the

sitter, unaware of being sought by the lens, doesn't arrange himself expressively, doesn't fall into the pose so as to assume the guise of an Image. This is what Barthes calls "the mortiferous layer of the Pose," the zero degree offering instead the utopia of an escape from the pose's assumption of meaning.[47]

It is tempting to associate Barthes with the avant-garde to which he himself belonged, the theoretical avant-garde of poststructuralism. Michel Foucault was working with the very terms of Barthes's opposition between writing and speech (as coercion versus freedom) when in *Discipline and Punish* he had set up the notion of *discourse* as disciplinary and therefore as the imposition of power. In the reception of Foucault this was vulgarized as *knowledge/power*, but Barthes's zero degree runs parallel to it in surprising ways. Barthes's focus on classical writing's exclusive use of the preterite and the third person (as in structural linguistics's definition of historical narrative) is contrasted with the oral forms Foucault identified as *discourse*. It was May '68 with the police's authorized entry into the sacrosanct precincts of the Sorbonne that Foucault saw as unmasking the supposed neutrality of narrative, as he understood that beneath the implicitly noncoercive transmission of knowledge from instructor to pupil lay discourse's imposition of the present tense and the first or second person—the instructor's *you* a command for response, as in the university examination, or, in another example of power, the police interrogation. Foucault's *discourse* is not Barthes's zero degree, but its opposition between *narrative* and *discourse* sets up the parallel structure of the conflict between classical writing and speech. Here Barthes joins the history of his own avant-garde in submitting to the summons of his contemporaries, "at the very moment," as he said, "when general History imposes a new problematics of . . . writing."[48]

Nothing, this spume, Virgin Verse — *The white care of our canvas*

Like Nauman, Marcel Broodthaers can be mistaken for a conceptual artist, antagonistic to the medium. His works have mimicked installation, as they mount imitations of museum galleries holding showcases filled with precious objects. With its concern for the history and medium of painting, his little film *L'analyse d'un tableau* (1973–1974) overturns this idea of Broodthaers

44

as a conceptualist. Structured as the pages of a book, slowly turned, the film begins with a nineteenth-century seascape through which a schooner sails on turbulent waters. The pages thus recall a history of art, beginning with Manet's marine paintings and moving toward the impressionist concern with sailing. Cutting to close-ups of the boat, this history makes a great leap forward into modernism when the weave of the white canvas sail fills the screen like a triumphant, abstract monochrome. We cannot miss this culmination, calling to mind Stéphane Mallarmé's toast to the blank white page as the support for poetry itself:

Salut
Nothing, this spume, virgin verse
Only to point to the cup;
So afar many a troupe
Of sirens drowns in reverse.
We navigate, O my diverse
Friends, me now on the poop
You the sumptuous prow to reap
Lightnings and seasons perverse;
A fine ivresse brings me
Fearless of its very pitch
To bear upright this salute
Solitude, reef, star
To whatever is worth
The white care of our canvas.
[*Le blanc souci de notre toile.*][49]

This toast to the medium renders Marcel Broodthaers another knight.

And . . . alphabets — *26, as in gas stations*

The triple-decker novel, published month by month, had to be fugal, a complex of narratives interwoven as the master plot unfolded. Dickens was the master of the master plot as his narratives in *Bleak House* interspersed Esther's story with that of Lady Dedlock, and hers with Chesney Wold, its servants,

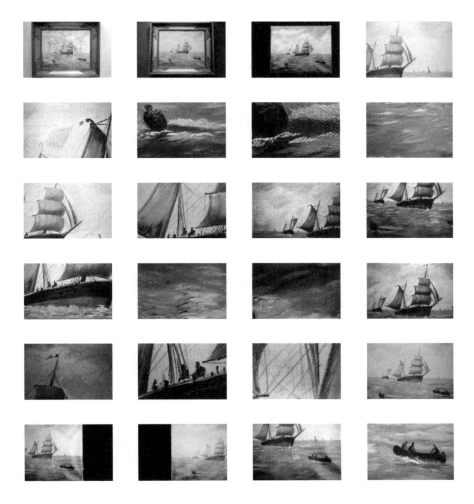

Figure 1.25
Marcel Broodthaers, stills from *L'analyse d'un tableau*, 1973–1974. 16 mm, color, 4 minutes 15 seconds. Courtesy of the Estate Marcel Broodthaers and Marian Goodman Gallery, New York. © 2010 Artists Rights Society (ARS), New York/SABAM, Brussels.

Figure 1.26
Marcel Broodthaers, slides from *Bateau tableau*, 1973. Projection of 80 slides of the painting *Un tableau représentant le retour d'un bateau de pêche*. Courtesy of the Estate Marcel Broodthaers and Marian Goodman Gallery, New York. © 2010 Artists Rights Society (ARS), New York/SABAM, Brussels.

its satellites—Mrs. Rouncewell and her prodigal son, George; Lawrence Boythorn in eternal dispute with Sir Leicester. Added to Lady Dedlock is the character "Nemo," and to Chesney Wold the lawyer Tulkinghorn. Jarndyce and Jarndyce provides the breathless plot line, with its multiple deaths and disappointments. The ease with which Dickens introduces themes only to drop them temporarily feels like writerly improvisation, the more accomplished the more it is complex; this is an instance of Cavell's *automatism*, wrought by the serial form of the *feuilleton*'s publication, as the plot follows its inexorable way.

In counterpoint to this fugue are the fortunes of its protagonists, each awaiting the settlement of the impermeable Jarndyce will to bring resolution to his life: mad little Miss Flite, Richard and Ada, and Gridley, the man from Shropshire.

Jarndyce and Jarndyce, a trial endlessly stopping and starting according to the appearance in Chancery of the Lord High Chancellor, is outside the narrative's horizontal thrust. The irresolvable case is vertical—a barrier—what Barthes would call the culture of the signifier, defining it as "a site of bliss." Taking his pleasure in the signifier's elaboration—as it drops, for instance, into description of the fogs of London and the filth of the brickyards—the reader is bidden to linger over "the blisses of language" so as to resist his impatient rush past the descriptive, vertical interruption into the horizontal thrust of the story.[50]

For Barthes there are two readers for every text. First are the "enemies of the text": "fools of all kinds, who decree foreclosure of the text and of its pleasure, either by cultural conformism or by intransigent rationalism (suspecting a 'mystique' of literature) or by political moralism or by criticism of the signifier or by stupid pragmatism or by snide vacuity or by destruction of the discourse, loss of verbal desire."[51]

"The other reading skips nothing," Barthes continues: "it weighs, it sticks to the text, it reads, so to speak, with application and transport, grasps at every point in the text the asyndeton [i.e., omission of the conjunctions that ordinarily join coordinate words or clauses, as in, "I came, I saw, I conquered"] which cuts the various languages—and not the anecdote."[52]

Not presuming to rise to the pleasure of the Dickensian text, I have wanted to structure *Under Blue Cup* fugally, the master narrative of the brain's remembering and forgetting, interspersed by alphabetically organized aphorisms—

Figure 1.27
William Kentridge, drawing from *Stereoscope*,
1998–1999. Courtesy of the artist and Marian
Goodman Gallery, New York/Paris.

intended to provide their own pleasure—as the reader recognizes the way the aneurysm's wash clamps both with stains and the oil leaked onto the parking lots, clamping as well with the smears of Kentridge's erasers. The first chapter's story is the "who you are," of both the aneurystic subject and the subjects of aesthetic tradition. The network of synapses generates alphabetic fullness, moving A to Z. Chapter two tells the story of Documenta X and its impresario Catherine David's imprecations against the white cube. In lingering over description, it evokes the progression of Documenta's installations. Its subplot is the emergence of the heroes of the book, the artists I deem the "knights of the medium." These seem to call for the return of alphabetic aphorisms to rhyme with the aesthetic pleasure I take both in experiencing this mighty work and narrating its visual bliss. L through Y seemed necessary here.

50

two
ON THE ROAD

(2) as though I were an athlete being trained to leap over the puddles in my brain

Kassel. Summer 1997. The first flood of visitors is disgorged into the Haupt-bahnhof, 1,200 at a time, since train is by far the easiest way to reach this city tucked into a corner of West Germany, nestled up against its one-time East German rival, a display of industrial bustle and commercial wealth developed at the outset of the Cold War to shame its Communist neighbor.

Into Kassel's squares and parks and along the tracks of its subway on their way to Documenta X, the grand, international exhibition of contemporary art, assembled every four years in this outpost of stained brick and sooty glass, 1,200 visitors a day will flow. Will flow through the subterranean corridors of the station past the panels of yellow tiles framed with strips of red, themselves the ground against which the first exhibit of this exhibition meets them with

a soft, technicolor glow. It is a light box bearing a large Ektachrome transparency, in imitation of the advertising panels mounted in so many other stations and public vehicles in the West. The photographs are of poor and homeless people, in sharp contrast to this swell of sleek voyagers with their determined gait and their rapt faces.

Will flow, now sullied by this, Jeff Wall's reminder of the fealty of every form of art to commercial use and financial gain. Will flow up the station's stairs and out along the subway tracks in the bright August sun of a Sunday. Will discover that no available surface along this promenade toward the distant park of Documenta is bare of its exhibits, now pitched within the city's every cranny. Will thus flow past the work Lois Weinberger placed within the tracks themselves, a brush of bright yellow-green fanning the interstices between the ties, little patches of ground exposed by tearing up the asphalt so that these plants, brought from North Africa, Israel, and Syria, can acclimate themselves to foreign soil. Weinberger speaks of them as "new immigrants" and explains that the plants symbolize the harmony of different cultures.

The human stream is deaf to this geopolitical form of reasoning. Its component individuals, used to looking for art, see the feathery palmettes obscuring the geometry of dark track and repetitive ties. See, then, the strictures laid down by so many abstract artists, Mondrian in the lead, against the admission of nature into painting, a natural color and form that will mask and disrupt the strict organization of the line.

Hans Hässler, still in his train conductor's uniform, is in the front of the human stream, which he now diverts up a gravel path flanked by bushes glowing with flowers, toward a concrete shed lowering at the stream as though it were a bunker left over from the last war. Leads them to the large rectangle of glass that should open the inside of the shed to view. The front of the stream

Figure 2.1
The gray train to Kassel. © iStockphoto.com/
AndreasWeber.

Figure 2.2
A view of Kassel. © iStockphoto.com/
AndreasWeber.

pushes against the pane, reflecting itself in the glass now shadowed by the human forms. Within each dusky silhouette, one of the shed's inhabitants thus becomes visible, and in this way an immense brown and white pig marries its haunches and snout to the supple reflection of Documenta's guest.

The *Pig Hut*, as this exhibit is known, is the work of Rosemarie Trockel and Carsten Höller, and they, like Herr Weinberger, have an explanation for this work. Pigs and humans have similar nervous systems, they say, so they probably feel the same things. The stream has no way to know the psychomedical part of the reasoning. It approaches under the auspices of art and so it recognizes the pigs as readymades: humble, ordinary objects imported into this festively aesthetic space and thus invested with the condition of "art" by the mere fact of occupying its domain. By the same token, of course, the reflection in the glass renders the visitors themselves into readymades, making the corrupted stream even dirtier as it flows on toward the first of Documenta's official buildings, Kassel's Fridericianum.

"The white cube is over": a film

Documenta x's director is Catherine David, an ardent Frenchwoman, with her own set of explanations and reasons. She has planned this procession from train station to exhibition park as a kind of filmic sequence carefully edited with one display juxtaposed to another: a series of jump cuts and dissolves. As she explains it: "Like a film, Documenta is a long and patient process of montage. Working from a more or less coherent script, sequences are isolated and thought out; when their internal structure is established, they are spliced

Figure 2.3
The blue train to Documenta. © iStockphoto.com/
AndreasWeber.

Figure 2.4
The Fridericianum, Kassel. © iStockphoto.com/
AndreasWeber.

Figure 2.5
Lois Weinberger's installation of plants as *Gastar-beiter*, from "A la rencontre de l'art contemporaine, Catherine David et la Documenta X." Aired on Arte, August 20, 1997.

Figure 2.6
The building housing Carsten Höller and Rosemarie Trockel's *Pig Hut*, from "A la rencontre de l'art contemporaine, Catherine David et la Documenta X." Aired on Arte, August 20, 1997.

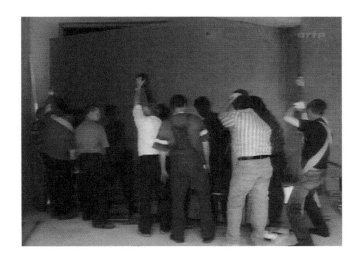

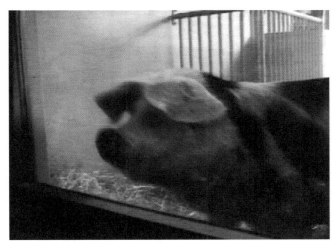

Figure 2.7
Visitors to Carsten Höller and Rosemarie Trockel's
Pig Hut, from "A la rencontre de l'art contemporaine,
Catherine David et la Documenta x." Aired on
Arte, August 20, 1997.

Figure 2.8
Carsten Höller and Rosemarie Trockel's *Pig Hut*,
from "A la rencontre de l'art contemporaine,
Catherine David et la Documenta x." Aired on
Arte, August 20, 1997.

into the whole." Her flow is cinematic, not aquatic, and her background is not Kassel's Fulda River but the most contemporary aesthetic position—what she sees as the leading edge of the avant-garde. "Unless you are naive, or a hypocrite, or stupid," she tells her interviewer, "you have to know that the white cube is over."[1] This is Catherine David paying homage to Brian O'Doherty, the conceptual artist and critic whose influential story of the white cube, told in *Artforum* and elsewhere,[2] recounts the history of the cube's appearance as the canny accomplice of the modernist artist himself, just when the museum and art gallery, in their raw architectural purity, have become the naked *sign* of art. *Inside the White Cube* points to this implicit condition of modern art that is the neutralized space of the gallery, as though suspended outside time and space: "The gallery is built according to laws as rigorous as those that presided over the churches of the Middle Ages," O'Doherty writes, trying to account for modernism's commitment to autonomy and purity. "Exterior space must not penetrate such a box—thus windows are generally condemned. The walls are painted white. The ceiling is the source of light deprived of location." "Aesthetic chamber" consecrated to a "sacramental dimension," the white gallery is "the only major convention to which modern art had to submit."[3] According to the laws of the white cube, the museum is purified of its refuse, bleached, exclusively dedicated to Art.

Robert Smithson, canny prophet of the evolution of modernism, invented the corollary spaces he called site and non-site at the end of the '60s. "Site" referred to a landscape exterior, imported into the purity of the white cube of the gallery by means of a map and shards of material excavated from that original site. Thus the site was transformed by its importation into "non-site" as indoor earthwork.[4] As non-site the white cube is deprived of its autonomy, its walls losing their percussive impermeability. As outside becomes inside, joined in a Moebius strip of mutual imbrication, the model of the aesthetic support is no longer the "sides of the pool" but the diorama of the museum of natural history.

Two spaces of art now mirror each other: the dealer's gallery and the artist's empty loft (as O'Doherty implies in the later title *Studio and Cube*). They are identified as "a ghetto space, a survival compound, a proto-museum with a direct line to the timeless, a set of conditions, an attitude, a place deprived of location."[5] Not only does this obsolete survivor now accept the invasion of the media, says O'Doherty, but it admits the curiosity of the viewer, who ob-

scenely wants to eavesdrop on the very act of creation in the space of its production.[6] And Catherine David's "film," this processional along the foliated tracks, is a sermon preached in the service of this revelation. The white cube is the now-outmoded emblem of art's supposed autonomy; of its withdrawal from the everyday; of the purity with which it pursues goals and practices specific to itself. The white cube is also, of course, the space of museum hall or art gallery, and so its vaunted "purity" is already defiled by the interests of commerce. If the abstract work is ineluctably a commodity and the white cube unavoidably a market, a kind of practice has dedicated itself to the repeated demonstration of this fact. It is called installation art because its first purchase on the commodification of the aesthetic object is the place of that object's display. As the modern gallery space, the white cube is itself a readymade, to be filled with other readymades that will, like the pigs of Trockel and Höller's bunker, instigate a "critical reading" of the nature of the space itself, exposing its underlying dirt, manifesting the contradictions secreted within it.

Catherine David's "film," conceived as preface to Documenta, is a sequence of such installations, a repetition of lessons on the collapse of the white cube, a processional flow over the industrial grime of Kassel. As she says, the film arises from "a more or less coherent script," what one could call a narrative about the obsolescence of the white cube. Script and narrative are themselves the symptoms of the demise of modernist art, which had fought a century-long battle against the entrance of the textual—of the literary, the anecdotal, the allegorical—into the visual. The purely visual reveals to its observer the force and unity of its structure in the blink of an eye. It has no need of literature's sequential unfolding, its temporal dilation; no need and thus no place. Just as centuries ago the guilds had established the multiplicity of Art as a "singular plural," their doctrinal separation of seeing from telling dates to the Enlightenment when Gotthold Lessing wrote his treatise *Laocoön* (1766) to separate the arts of space strictly from those of time.

The narrative form of Documenta's installations is a litany about the geopolitical significance of Kassel, a place not far from the site of West Germany's intercontinental ballistic missiles pointed directly at the former Soviet Union. From the opening of the "script" in the railroad station to its close in Martin Kippenberger's portable subway entrance, a polygonal solid racked as though caught up in the distortions of axonometric perspective, which he explains as an emblem of the East/West axis, Documenta's narrative repeatedly

Figure 2.9
Catherine David, from "A la rencontre de l'art
contemporaine, Catherine David et la Documenta x."
Aired on Arte, August 20, 1997.

Figure 2.10
A white-walled gallery. © iStockphoto.com/xyno.

enrolls art in the politics of Cold War Germany, from Weinberger's "new immigrants" to Trockel and Höller's complacent *Schweine* in their threatening bunker.

It was conceptual art that had decreed the substitution of the visual by the textual, as in Kosuth's insistence that art should now take the form of the proposition. And in calling a halt to the visual as the mainstay of art's medium, it was also declaring the end of the disembodied viewer, the modernist spectator as nothing but a point of view, a mere vantage within the apparatus of the work's perspective. Documenta's guests are thus spectators with bodies; they are gendered, nationalized, each bringing a set of cultural identities, ethnologies, and expectations. As the narrative tells the story of the end of art's autonomy, it also declares a close to its specificity. There is nothing left of painting or sculpture in this efflorescence of the readymade. And the narrative also constructs a different viewer, neither disembodied nor naive nor a hypocrite but now a part of the politics, not the aesthetics, of art. In her indefatigable travel to find the artists to be included in Documenta, Catherine David is an admirable administrator of the "end of the white cube." This makes her the natural adversary of my argument in support of the medium, which she has already declared to be either hypocritical or stupid.

Learning from Dickens — *The white cube is over: a theory*

Hortensia Voelkers is in the upstairs office of the Hauptbahnhof, preparing to address the assembled artists and critics who will serve as official guides for Documenta's puzzled guests.

Hortensia, intensely proud of the responsibility Catherine David has invested in her, idolizes the woman she addresses as Kha-tee. She understands that as the German assistant and administrator for Documenta's director she needs to be, as she puts it, "the accomplice who should be her double."

To be Catherine David's double seems like a distant dream. She visualizes Kha-tee's French elegance as she picks her way through the materials in the studio of the artist she is visiting, dressed, as she always is, in her black pants suit, her tightly sheathed legs deliberately extending below its jacket like the talons of an exotic bird.

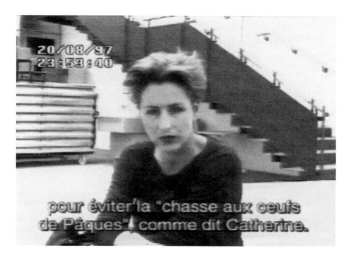

Figure 2.11
Hortensia Volker, from "A la rencontre de l'art
contemporaine, Catherine David et la Documenta x."
Aired on Arte, August 20, 1997.

Hortensia has chosen this site as the opening of her address to the guides because the very idea of mounting art in a working train station will instantly "enlarge the traditional idea of a place to show art." It will set the scene in a way that will clarify from the start that the visitor is "to avoid chasing after Easter eggs," she smiles, "as Catherine David would say."

The text for this lesson is pure Catherine David; it reads: "The white cube is over."

Hortensia begins. "What is the white cube? Why a cube? And why white? Is it a cube because it descends from royal palaces transformed into museums to display imperial treasure? Yes. These are the rooms of the former rulers of Europe still stamped with their earlier claims to authority and grandeur. Is it white because it is to express the idea of purity? The notion that this sancti-fied box can be fortified against the interference of any claims from without? Yes. Nothing 'extraneous' is to enter—nothing political, ideological, sacred. Why is it over? And if exhausted, what is to replace it? What will substitute itself for the white cube?"

A prospective guide in jeans and a tee shirt says, "Black cube?"

Hortensia is delighted. "Ja, ja!" she exults. "The black cube is the movie house, the room darkened for TV, the space of media. As Catherine David would say: 'I don't agree with authenticity, purity, or this strong ontological opposition between art and the media.' For her, any intense aesthetic experi-ence now has to do with media."

"And what," Hortensia continues her lesson, "is ontological opposition? Is it the idea that art has an essence that is specific to itself—not shared with the essence of media, which is entertainment? Yes."

"But Catherine David and I," she persists, "planned the introduction to the exhibition as an exercise in media. She thinks of the procession from the station to the park as a film sequence, spliced together, edited, like an explanatory movie. And what is it explaining? That here in Kassel we are in a black cube, not a white cube? Yes."

Before the aneurysm washed my memory away, I had been a writer, my criticism full of what I hoped were supple readings of contemporary art. After the flood, my writing had not become more fluid but wooden, unbear-able. Nonetheless Kassel's installations demand a rich outpouring of descrip-tion for tracking Documenta's "film." Who is a master of description giving his reader the incentive to pursue the flow of his text (and not to skip)? I

Figure 2.12
Catherine David, from "A la rencontre de l'art
contemporaine, Catherine David et la Documenta x."
Aired on Arte, August 20, 1997.

think of Charles Dickens, especially *Bleak House*'s London with the fog we willingly penetrate. To lead us through this dismal mist, Dickens constantly invents characters whose movements we are glad to follow. Hortensia's sermon will be familiar to readers of *Bleak House*. It is pure Reverend Chadband, as he preaches in the law stationer Snagsby's shop. Listen to the Reverend of the Harmonic Meeting: "My friends . . . peace be on this house! . . . What is peace? Is it war? No. Is it strife? No. Is it lovely, and gentle, and beautiful, and pleasant, and serene, and joyful? Oh, yes! Therefore, my friends, I wish for peace, upon you and upon yours."[7]

Life support — *The pleasure of the text*

It seems all too obvious to ask. If Kha-tee and Hortensia are symptoms of the malaise of contemporary art, what is the disease?

Roland Barthes writes of "the pleasure of the text." How is this pleasure lost? This, he says, is by the reader's refusal to slow down in his hurry to get to the *point* of the narrative (by skipping description, for example, as "mere" intermittence). Slowing down requires a delicious lingering over the signifier and the signified's vertical set of substitutions for a given noun, in defiance of the horizontal, deictic drive of the narrative's succession. Barthes calls this vertical ascent the textual "cut," as well as its *asyndeton*—the *ritardando* of the pronominal sentence's omissions, as in "like father, like son." This delectation is what Barthes names "the culture of the signifier"—that culture Mallarmé called "the ultimate veil that always remains." In the domain of the visual, slowing down is expectation as a push off the side of the pool, so that the surface of the work can touch base with the white cube—allowing Ubu's prisoners to fall past the rising filmstrip spooling back into the projector's gate. Barthes's "text" is *Under Blue Cup*'s "support" as sought for and discovered by vision.

Barthes blames the rush to politics for the eclipse of the culture of the signifier, calling the supporters of this eclipse "the enemies of the text." As we have seen, his contempt for them is limitless: "fools of all kinds, who decree foreclosure of the text and of its pleasure, either by cultural conformism or by intransigent rationalism (suspecting a 'mystique' of literature) or by political

moralism, or by criticism of the signifier or by stupid pragmatism or by snide vacuity or by destruction of the discourse, loss of verbal desire." In distinction to this conformism Barthes names the text's pleasure "asocial," and, terming it "bliss" as well, he speaks of an "erotics" of the text.[8]

Here we cannot but recall Susan Sontag's impassioned plea at the end of *Against Interpretation* for an "erotics of art" to displace the compulsive contemporary drive toward its "hermeneutics."[9]

The obsessive politics of the Documenta x installations, harping on the proximity of West Germany to its one-time enemy on the east, is an example of Barthes's "political moralism," more currently having given way to the "cultural conformism" of relational aesthetics. Declaring the replacement of production by the service economy, relational aesthetics celebrates the eclipse of the "asocial" nature of the text by a constant summoning of social exchange.[10] Its major theorist, Nicolas Bourriaud, says, "Art production now indexes the service industry and immaterial economy more than heavy industry (as it did with Minimalism). Artists provide access to certain regions of the visible. . . . They don't really 'create' anymore, they reorganize."[11] In defiance of Barthes's asocial character of the text, relational aesthetics summons a lively and convivial model of the social. Instead of fixed identities and community, its sites offer provisional gatherings or ad hoc groups temporarily forming around similar interests.

For Bourriaud, art is a way of "learning to inhabit the world in a better way"; it's not about "utopian realities" but "ways of living and models of action within the existing real, whatever the scale chosen by the artist." Further, "the exhibition is the special place where such momentary grouping may occur [because it] gives rise to a specific 'arena of exchange.'" The criterion of judging this new work would be "the symbolic value of the 'world' it suggests to us, and the image of human relations reflected by it."[12]

Art is summoned to transform the traditionally bourgeois institutions of the public sphere. Here the *text* is indeed overwhelmed by what Bourriaud calls the transformation of the museum from a space of contemplation to a site of experiments in "how to live."

Hearing such a manifesto, we have to ask: What can this be but an insistent "hermeneutics" of the text?

Here are Bourriaud's examples: "Rirkrit Tiravanija organises a dinner in a collector's home, and leaves him all the ingredients required to make a

Thai soup. . . . Carsten Höller [creator of the *Pig Hut*] recreates the chemical formula of molecules secreted by the human brain when in love. . . . Pierre Huyghe summons people to a casting session. . . . Anyhow," Bourriaud concludes, "the liveliest factor that is played out on the chessboard of art [where is the medium's knight?] has to do with interactive, user-friendly and relational concepts."[13]

The "culture of the signifier" is a culture of the medium—in Barthes's eyes, a way of lingering over the "cut" which exposes the signifier's opening onto its support, a slowing down Barthes takes pleasure in, thus:

> Is not the most erotic portion of a body where the garment gapes? In perversion (which is the realm of textual pleasure) there are no "erogenous zones" (a foolish expression, besides); it is intermittence, as psychoanalysis has so rightly stated, which is erotic: the intermittence of skin flashing between two articles of clothing (trousers and sweater), between two edges (the open-necked shirt, the glove and the sleeve); it is this flash itself which seduces, or rather: the staging of an appearance-as-disappearance.[14]

There is nothing "user-friendly" about this opening that binds signifier to support, ignoring the current contempt for the white cube's leverage on the completeness of illusion, like that of the sides of a pool, a flat surface against which the swimmer pushes off.

Kha-tee's death of "ontological opposition" and Hortensia's acceptance of the end of the white cube are the symptoms of foreclosure, of the "loss of desire," of the post-medium condition's refusal of bliss. There are Roland Barthes's pleasure, Susan Sontag's erotics, *Under Blue Cup*'s sides of the pool; to forswear this pleasure in the interest of "political moralism" is the disease.

Milan Kundera — *The unbearable lightness of kitsch*

If the pig hut and the palmettes are not instinctively felt to be meretricious, arbitrary, and thus the simulacrum of art rather than the real thing, this is because kitsch has become the polluted atmosphere of the very culture we

breathe. Their identity as kitsch derives from their feckless indifference to the idea of a medium, so long ago condemned by Greenberg's admonishment in "Avant-Garde and Kitsch." Kitsch he defines as the corruption of taste by the substitution of simulated effects for that recursive testing of the work of art against the logic of its specific conditions, a testing he named "self-criticism." Milan Kundera was to go much further and more violently into a condemnation of kitsch in his novel *The Unbearable Lightness of Being*, in which kitsch is summarily translated as "shit." The circumlocution about man's anatomical needs driven by an absurd squeamishness is what, Kundera writes, makes "human existence lose its dimensions and become unbearably light."[15] This is the "unbearable lightness" of installation, its simulation of culture now apologized as a parade of "black cubes," the fake intransigence of Kha-tee's "exercise in media."

The epithet *fake* opens directly onto what Cavell calls the *fraudulence* that not only hounded the unfolding of modernism, but has now become "endemic in the experience of contemporary" art.

> It is . . . significant about modernism and its "permanent revolution" that its audience recurrently tells itself the famous stories of riots and walkouts and outrages that have marked its history. It is as though the impulse to shout fraud and storm out is always present, but fear of the possible consequence overmasters the impulse. . . . It is not merely the threat of fraudulence and the necessity for trust which has become characteristic of the modern, but equally the reaction of disgust, embarrassment, impatience, partisanship, excitement without release, silence without serenity.[16]

"Is a canvas covered with a single layer of pigment art?" he asks. "A familiar answer is that time will tell. But my question is: *What* will time tell? . . . In waiting for time to tell that, we miss what the present tells—that the dangers of fraudulence, and of trust, are essential to the experience of art. . . . Modernism only makes explicit and bare what has always been true of art."[17]

Under Blue Cup is a polemic, adamantly shouting "fake" and "fraud" at the kitsch of installation. The effect of the genuine is not lost to memory, not swept away. A polemic is a call to remember, against the siren song of installation to "forget."

New life — *On the road*

In her heroic pursuit of the contemporary for Kassel, Catherine David is ricocheting around the Western Hemisphere in a dizzying sequence of conveyances: trains, planes, ocean liners, limousines. She is chasing the very Easter eggs of Hortensia's sermon, for at the end of each trip she hopes to find the perfect work for Documenta, a golden spike to drive into the coffin of the white cube.

Except for her elegant suit, she could be a character from Jack Kerouac's *On the Road*, as back and forth across the continent Sal Paradise, Dean Moriarty, and their companions rocket like pinballs knocking against the buffers and sides of the tray and making lights blink in the panel above. The feverish intensity of their travel, its dogged obsession and its frantic restlessness, has the road itself as its support or what, in another way of speaking, could be called its "medium." Kerouac wrote the book on one massive roll of paper. Changes of typing sheets, he thought, would interrupt the flow of his language. In the end, the book formed a single track of words 120 feet long—a road of verbiage. Kerouac writes: "As a seaman I used to think of the waves rushing beneath the shell of the ship and the bottomless deeps thereunder— now I could feel the road some twenty inches beneath me, unfurling and flying and hissing at incredible speeds across the groaning continent with that mad Ahab at the wheel. When I closed my eyes all I could see was the road unwinding into me."[18]

The dislocation tracked by Kerouac and the poets who came to be known as the Beat generation was measured by the cities they traversed as they hitchhiked coast-to-coast, each the name of another set of expectations: Council Bluffs, Shelton, Columbus, North Platte, Ogden, Cheyenne, Denver.

Ed Ruscha, the L.A. artist each of whose paintings bears a logo-like word across it, discusses his development with the curator Walter Hopps, who asks about the work branded SWEETWATER, which Ruscha says was the first word painting he made. Hopps continues biblically, "So in the beginning there was the word, and as best we can remember it, the word was Sweetwater." To which Ruscha adds, "Yes. Sweetwater was a town in Tennessee that I hitchhiked through when I was going down to Florida in 1952. Dublin, Georgia, was another town . . ."[19]

Figure 2.13
Ed Ruscha, *On the Road, An Artist Book of the
Classic Novel by Jack Kerouac*, 2009. Designed
by Ed Ruscha, 228 pages, 220g Hahnmühle
paper, Fuji Crystal Archive Paper, leather-bound
hardcover and slipcase. © Ed Ruscha. Courtesy
Gagosian Gallery.

Figure 2.14
Kha-tee as stewardess, from "A la rencontre de l'art
contemporaine, Catherine David et la Documenta x."
Aired on Arte, August 20, 1997.

Peeling off the layers of Ruscha's experience from his San Francisco days in 1968 yields the names of the Beat heroes, like Kerouac. "Beatniks were in," he says, "and that lifestyle seemed appealing to us all. Jack Kerouac and so on had a strong effect on all of us" (114). Neal Cassady, the Dean from *On the Road*, is another. Q: "Larry Clark, James Dean, Neal Cassady, Bob Dylan, and Ed Ruscha. See any correlation?" Ruscha: "All ramblin' souls?" (335).

The image of migration captured Ruscha's sensibility as a young man and drove him west: "In the early 1950s I was awakened by the photographs of Walker Evans and the movies of John Ford, especially *Grapes of Wrath*, where the poor 'Okies' (mostly farmers whose land dried up) go to California with mattresses on their cars rather than stay in Oklahoma and starve. . . . On the way to California I discovered the importance of gas stations" (250).

Asked about L.A.—"What was it about L.A. that caught your eye artistically?"—he answers: "It was a kind of contemporary decadence that I responded to and I suppose it had a lot to do with the cars and gas stations and that sort of thing" (283). Or then: "I seemed to be drawn by the most stereotyped concepts of Los Angeles, such as cars, suntans, palm trees, swimming pools, strips of celluloid with perforations; even the word 'sunset' had glamor. West was hot. East was cold. This was new life. . . . I think that Chicano clothing and car styling are some of the most worthwhile contributions that L.A. has ever produced" (242–243).

Ruscha's interlocutors fasten on the subject of cars as a way of unifying his work; Henri Barendse asks: "You've said, half-seriously, I suspect, that you came to California because you like palm trees and hot rods. You've done the book of palm trees but never one of cars. It seems like cars are a missing link in the books, quite literally, since they would tie them together, be the conduit between the pools, apartments, and of course, the parking lots and gas stations. Perhaps I'm taking things too literally again." Ruscha, who (to the amazement of Andy Warhol) never allows the human subject to register in his photographs, answers: "No, cars are too much like people. It would be hard to make a statement about cars without flavoring it too heavily. I think cars would have been . . . I just couldn't do anything with them. I picked more or less neutral subjects that would not ordinarily be chosen as subjects for art" (213).

Barendse: "What about the idea of mobility in your work as a possible reflection of one aspect of American culture: gas stations, the automobile and car culture, the importance of mobility in our life? I suspect that not

Figure 2.15
Ed Ruscha, *Sweetwater*, 1959 (destroyed).
Oil and ink on canvas. © Ed Ruscha. Courtesy
Gagosian Gallery.

very much of this is conscious, but are you willing to acknowledge that it plays a role at all?" Ruscha: "Yes, it sure does. I used to have a 1939 Ford. I'm more interested in the function of getting around than I am in the stylistic happenings of cars" (161–162).

The restlessness recorded by Kerouac is registered by Ruscha: "I used to drive back [to Oklahoma] four or five times a year," he says, "and I began to feel that there was so much wasteland between L.A. and Oklahoma that somebody had to bring the news to the city. Then I had this idea for a book title—*Twentysix Gasoline Stations*—and it became like a fantasy rule in my mind that I knew I had to follow" (232–233).

Oil on canvas — *The medium is the rule*

Ruscha's "idea" didn't result from his actually having counted his pit stops along the highway, but from a number he unconsciously associated to a series, that series possibly being the letters of the alphabet. *Twenty-six* emerged for me as well, for the arrangement of the little fragments of this text that arose as associations one to another, and appear here like a synaptic network. The alphabetical tissue has become the *automatism* of *Under Blue Cup*, a pattern generated from the rule of remembering.

The word *medium* sounds frequently in Ruscha's answers to Barendse, and it is acknowledged in the titles of his various projects. *Stains*, for example, is witness to Ruscha's frustration with oil on canvas: "Right now," he says, "I am out to explore the medium. It's a playground or a beach so I'm going to send as much sand up in the air as I can! I think the next time I'll print with iodine. I have to be in control of the medium. The organic elements have to combine satisfactorily. What I'm interested in is the possible range; also in the use of a *processed* media. New mediums encourage me" (30).

The alphabet's twenty-six letters are a medium in the eyes of the theorists of media (as transmission systems) who tie the alphabet to the outmoded medium of the book (as in McLuhan's *Gutenberg Galaxy*, explored above). Computers have surpassed the alphabetic order by transcoding all symbolic systems into streams of numbers.

The medium of oil on canvas was coming to an end for Ruscha: "I'm painting on the book covers. I guess I'm just looking for another support. Maybe I'm moving away from the canvas, but I can't predict. I still paint on canvas, but I think there's another shift about to happen somewhere, maybe not so radical, but at least one that I know I will want to stick with" (323).

As Barendse suggested, cars functioned as the support Ruscha stuck with, through the parking lots, the gas stations, and the *Sunset Strips*, which he rephotographed from his car window regularly, every year.

When Ruscha says, "maybe I'm moving away from the canvas," he is echoing the dissatisfaction of that generation of painters who emerged in the period called "postmodernism," as one of the three things. Themselves having "moved away from the canvas," painters such as Cuchi and Clemente defied the laws of modernist abstraction to challenge the flat surface with Herculean heroes and monsters. With this eclipse of painting's traditional support, Ruscha was forced to "invent" a medium in painting's stead. It was at this impasse, and possibly with the example of Kerouac in mind, that the car became the continuous frame of his work. As a "technical support," the car offered the repertory of its own underpinning—from its road (like Kerouac's) to its gas stations and finally its parking lots. In Ruscha's work, from books to paintings, the car is made a recursive structure, as the grid of the *Parking Lots* declares the flatness of the book's pages or the gas stations articulate the highway that supports the car in turn (like Kerouac's road "unwinding into [him]"). Kerouac's road is a stream of restless expectation, not the staccato of alphabetic succession.

Nothing about the car could be said to be a traditional medium; rather it is what Ruscha "invents" in order to make a recursive structure for himself that will signify in the way older mediums had done. "I'm painting on the book covers," we remember him saying, "I guess I'm just looking for another support." This book is calling such another a *technical support*.

76

Oil on tarmac — *The aneurysm of the stain*

As Ruscha uses the word, *medium* can mean either the element in which color is suspended, traditionally oil but, for his *Stains*, iodine, chocolate syrup, chutney;

Universal Studios, Universal City

Figure 2.16
Ed Ruscha, figure 18 from *Thirtyfour Parking
Lots*, 1967. 48 pages, 31 illustrations (one foldout),
10 × 8 × ⅛ in., weight 6¼ oz. Glassine dust jacket;
sewn binding. First edition: 2500 copies, 1967.
Second edition: 2000 copies, 1974. © Ed Ruscha.
Courtesy Gagosian Gallery.

Figure 2.17
Ed Ruscha, *Thirtyfour Parking Lots*, 1967. 48
pages, 31 illustrations (one foldout), 10 × 8 × ⅛ in.,
weight 6¼ oz. Glassine dust jacket; sewn binding.
First edition: 2500 copies, 1967. Second edition:
2000 copies, 1974. © Ed Ruscha. Courtesy
Gagosian Gallery.

or it can be the technical support, traditionally stretched canvas, but for him cloth-bound book covers like taffeta, or the photography of the books' contents.

Besides the extravagance of his invention of matrices (axle grease and caviar is an example), Ruscha's interest in the idea of medium as a type of support also takes shape as a set of rules, as when he remembers: "I had this idea for a book title—*Twentysix Gasoline Stations*—and it became like a fantasy rule in my mind that I knew I had to follow."

Ruscha's "rule" led him to the car's exigencies—its need for gas and for places to park. Ruscha's stains not only flood the covers of his books, but mark the car's absence from the parking lot by the oil its crankcase has leaked on the asphalt. The smoky traces of Kentridge's erasures are also a kind of stain. He has an affection for the look of high-tech medical imaging such as CAT scans, sonar, and MRIs. As he says, "there is a great affinity between the velvety grey tones of an X-ray and the softness of charcoal dust brushed onto paper."[20] Ruscha's stains travel back down the history of recent painting to the 1960s and the advent of stain painting, also called color field: chroma poured into raw canvas to leave a lurid stain. In doing so, they function as the "memory" of the medium he is both abandoning and reinventing.

With his gasoline stations, Ruscha's *medium* has less to do with the physicality of the support than with a system of rules. This is the system Stanley Cavell had decided to call an *automatism*.

Polyphony — *Aesthetic automata*

The Greek word for *self* shared by the prefix for *auto*matism and *auto*mobile is suggestive in this context. For Cavell, as for Ruscha, the rules become necessary once the artist finds himself cut free of tradition and wandering haplessly in a field where "anything goes." It is only the rules that give not only a goal to invention, but the basis of judgment about the constant threat of fraudulence. If the rules embedded in an automatism allow the artist to improvise, this means, as Cavell says, we can imagine all music up to Beethoven as improvised.[21]

It is tempting to use Cavell's *automatism* as a substitute for *medium*, itself grown lexically toxic from its associations with what is seen as the reflex of

Greenberg's reductive dogma. Cavell intends *automatism* to open naturally onto the practice of a *medium*. Accordingly he writes,

> I characterized the task of the modern artist as one of creating not a new instance of his art but a new medium in it. One might think of this as the task of establishing a new automatism.... A modernist art, investigating its own physical basis, searching out its own conditions of existence, rediscovers the fact that its existence as an art is not physically assured. It gracefully accepts our condemnation to meaning—that for separate creatures of sense and soul, for earthlings, meaning is a matter of expression; and that expressionlessness is not a reprieve from meaning, but a particular mode of it.[22]

For *Under Blue Cup* this substitution would bring with it associations to surrealism and its "psychic automatism," only to have the rigor of the medium leach out into the chaos of unconscious mechanisms. There is nothing else for this argument, then, but to continue with the precision of *medium* and its associations to memory.

Quartet — *The medium is the music*

For Bach to *improvise* fugues in five voices, and for the performers of Schumann to *improvise* the closing cadenzas the composer has called for, is only possible because of the rules that derive from tonality. For Cavell, rules are another name for convention. The very convention, as we see below, that Viktor Shklovsky invokes as the "knight's move."

Rules — *The medium is still the frame*

When, having traveled to Dublin, Catherine David comes across the work of James Coleman, she is struck by its suppression of the white cube. The exacting projection of a sequence of slides synchronized with a taped soundtrack,

Coleman's work is usually set in the black cube. Because his slide tapes are like films, Coleman's blackened gallery is supplied with chairs on which its viewers may sit. The slide tape is familiar to Kha-tee from the billboards she's seen in train stations and airports. It's part of the culture of advertising so widespread in the West—a public form of entertainment to distract commuters and relax shoppers. Kha-tee has already chosen Jeff Wall's photo-billboards for Documenta's Hauptbahnhof. In distinction to Wall, Coleman's version of the slide tape seems to have as one of its rules that it will acknowledge this condition as entertainment, and to this end his characters are often lined horizontally across the slide as though taking a bow at the end of a play. Altogether its rules take the form of *auto*-reference. The staccato sound of the slides falling into place, as the carrousels ratchet forward, is imitated on the soundtrack of the work *I N I T I A L S*, when the tape's piping voice-over spells complicated words by rapping out the individual letters: e s o p h a g u s.

There is another rule Coleman has invented, which Catherine misses on her first viewing of his work, since her travels have exhausted her and she has relied on a set of familiar, deconstructive ideas to explain this vivid oeuvre. The human subject, she has learned from deconstruction's *différance*, has no innate "self," no essential "who you are"; instead, it is constructed. Nothing about it is biologically determined; it is, rather, a concatenation of social, ethnic, and even gender protocols to produce the roles each of us will play. Coleman's scripts, she decides, embody this process of social construction and the way individuals bend to its demands. In her reading of what she takes to be the politics of Coleman's work, she doesn't notice and doesn't ask about the peculiar choreography of his characters on the stage of their slides. Whenever there are at least two in the frame, they curiously interact by directly facing the camera rather than one another. To understand this arrangement, she might have thought of the way Roy Lichtenstein's lovers are always staring out of the comic book frame even while their speech balloons project the most tender intimacies toward each other ("It's . . . it's not an **engagement ring**, is it?"). She would have realized that the syntax of film is open neither to the cartoonist nor to Coleman, since the film can jump back and forth between a speaker's face and the person to whom he or she is talking, the alternation (as angle/reverse angle) happening in the blink of an eye.

For Coleman to imitate film's angle/reverse angle would be more "realistic" than this direct staring out of the window of the slide. But it would also

Figure 2.18
James Coleman, still from *I N I T I A L S*,
1993–1994. Projected images with audio narration.
© James Coleman. Photo courtesy of the artist
and Marian Goodman Gallery, New York.

be extravagantly distended in terms of the number of images needed to enact even the briefest of exchanges. It is thus more efficient for his actors to express their most fervent emotions as they both resolutely face the camera. So one of Coleman's rules could be called the "double face-out." He takes it from other forms of visual narrative: not only comic books, but also photo novels and advertising. What it supplies for him is a sense of the pressure of time that makes the nonstereotypical expression of intimacy so unlikely within the developed societies of the West. What it also furnishes is a reminder of the screen's physical surface as the underlying principle from which the rule derives. It was Roland Barthes who declared, counterintuitively, that the essence of film is not movement but stasis—Hollywood's photographic production still defining for Barthes the "genius" of cinema as a medium. The photographic still, he reasons, resists the unfolding plot of the film, pressuring against that plot something "counter-narrative," which allows for the invention of what Barthes calls a "new signifier." Accordingly, this opens the possibility of a new medium: what Barthes calls the "anecdotalized image" of the comic book, the photo novel, and the stained glass window.[23] To this we must add Coleman's slides.

Every media project (film, photography, video) Kha-tee finds on her travels leaves her triumphant—proof, if more were needed, of the demise of the white cube. If the white cube had been, for the many decades of modernism, the cornerstone for "specificity"—since, as Hortensia and the Documenta guides had agreed, it was the very source of the notion of "ontological opposition," the guarantor of the "purity" of the objects it contained—the black cube setting for these new works is the warrant, she believes, of their indifference to the problem of the artistic medium. From Coleman, her attention is drawn

Figure 2.19
James Coleman, still from *I N I T I A L S*, 1993–1994. Projected images with audio narration. © James Coleman. Photo courtesy of the artist and Marian Goodman Gallery, New York.

Figure 2.20
Roy Lichtenstein, *The Engagement Ring*, 1961. © Estate of Roy Lichtenstein.

to William Kentridge, a South African artist whose animated films pursue the problems of apartheid across the African veld with its mines and its slag heaps. Kentridge is another artist, however, who is inventing a set of rules. His technique is erasure; every line is a potential trace of effacement, a mark to be modified, each modification recorded by a frame of film. These frames are then run together in the projector to produce the animated movement of cinematic cartoons. This rule produces many of the sequences such as a car ride through the rain during which the view of the landscape is rhythmically blurred by the windshield wipers, their metronomic smear becoming recursive, an image of the very act of erasure. The car's interior is then the site of the traumatic memory that forms the narrative climax of *History of the Main Complaint*—as Kentridge's technique constantly narrativizes his own process. Erasure is to line what *Stains* is to drawing: two artists having discovered the same set of rules to make their process "perspicuous," as it resists the enclosing contours of traditional drawing.

It is easy to miss this coincidence, as Kha-tee does. But her attention is on the blackness of the space of projection; it is the Easter egg she is seeking in the obsessive persistence of her travels.

Swimming in the white cube — *Perspicuous representation*

During the summer of 1997 I am in Paris working on a book on Picasso and the problem of pastiche. Documenta x has just opened in Kassel, and every evening Arte, the cultural television channel collaboratively produced by France, Spain, Germany, Italy, and Britain, ends its news program with a short clip of Documenta's most eccentric installations. There are three minutes on the *Pig Hut*, three on the little exhibition in the Hauptbahnhof, three on the *Gastarbeiter* plants potted between the ties of the subway. The interview with Catherine David in the train continues from evening to evening as we track her travels from one continent to another. I hear her declare, "The white cube is over," with all the finality she is able to pour into this pronouncement, but it is equally clear to me, from what I know about contemporary practice, that she's wrong. Catherine David has become the antagonist to this book's crusade—its resistance to the collapse of the white cube.

Figure 2.21
William Kentridge, video still from *History of the
Main Complaint*, 1996. Courtesy of the artist
and Marian Goodman Gallery, New York/Paris.

The white cube is the base we touch with our eyes, the way the edge of the pool is the surface against which we kick in order to propel ourselves back through the water. As we shall see, this is like the wall's interception of the double images of Farocki's *Interface*. The rule generated by the medium allows us to kick off against the cube's resistant surface. It helps to think of the cube as a swimming pool rather than the room of a royal palace; this drains it of its "politics." The black cube of Hortensia's lecture is at cross-purposes with the white one since its darkness is meant to dissolve away the resistant, material surface, leaving one's eye no purchase. Darkness "extends" the projective reach of vision, but at the same time it "amputates" perceptual judgment. Darkness is, then, the atmosphere within which the narrative of film or television is suspended, bits of fantasy in an aqueous mist.[24]

During the '60s, young, independent filmmakers campaigned to stake out a version of the white cube for their medium, which meant forswearing the black cube's grounds of invisibility. Cinematic motion is based on the physiological fact of the "persistence of vision" by means of which any visual stimulus induces a ghostly copy of itself (called afterimage) which remains on the retina, as though suspended before our eyes, masking the slippage from that stimulus to the next. So we never "see" the replacement of one film frame by another; we cannot witness the movement of the filmstrip through the projector's gate. It is this invisibility that enables the illusion of continuous motion on which cinema rests. So many parts of the cinematic apparatus are invisible in just this way: the screen is not hard and percussive like the walls of the cube, but is instead permeable and unlocatable; sometimes it appears nearer to us than the image it supports, at others, further away, a kind of immaterial distance, like a cloud.

Independent film (sometimes called structural film)[25] endeavored to make all parts of the cinematic apparatus visible, perspicuous. Counterintuitively, it began with the movement of the filmstrip through the projector's gate. To disrupt the illusion, filmmakers such as Paul Sharits and Peter Kubelka scissored apart the celluloid strip to insert lengths of opaque black leader, or sometimes frames of a single, saturated color. The result was the experience of "flicker," the oscillation of information as though the projector were blinking against its own light. Still cutting against the grain of illusion, the next move was to batter the celluloid itself, producing a spatter of dirt or a tracery of

scratches to make the transparent veil flutter into view. As it did so, it hit the sides of the white cube, kicking off against them as a jolt to vision.

William Kentridge has developed his art far away from the centers of structural film. His drive to make the apparatus visible is not indebted to structuralists such as Michael Snow or Hollis Frampton or Paul Sharits. But Kentridge has achieved the realization of the strip moving through the projector, as in the falling prisoners sequence from *Ubu Tells the Truth*; he has also found the visual metaphors for making his own process perspicuous, which, since it is the erasure exacted on the drawing while the camera is still, takes place in secret. The screens of so many pictured medical instruments, with their smudged charcoal monitors, are to his surfaces as a type of stain.

Kentridge's *Felix in Exile* is the story of Felix Teitelbaum in a hotel room in Paris with his suitcase full of drawings brought from Johannesburg, drawings of the battered and mutilated victims of apartheid as they lay on the ground where they fell. As Felix surveys the bloodied forms, the drawings form a blanket for them, as though the bodies were buried in piles of autumn leaves. A wind seems to scatter this coverlet so that the sheets of drawings are tossed into the air around the corpses, their ghostly outlines dragging through space like so many cloths employed for the process of wiping out and smearing the line.

Kentridge's rule seems to be to make every part of his apparatus perspicuous, from the projector's gate to the action of his erasers. This pressure toward visibility runs counter to conceptual art's assumption that, now, language replaces vision, eclipsing the seen by the said. Indeed, for conceptualism, rules themselves are a grid of writing, as when Lawrence Weiner produces a work as a "proposition" (e.g., "a nine-foot square removed from the gallery floor"), assuming in turn that the proposition must be permuted through the following system:

1. The artist may construct the piece
2. The piece may be fabricated
3. The piece need not be built

Even Richard Serra, no conceptualist, understood his chosen materials of felt and lead to have given rise to a "Verb List"—as though to the rules of their eventual manipulation:

to roll
to crease
to fold
to store
to bend
to shorten
to twist . . .
to tear
to chip
to split
to cut . . .
to drop

Each of these verbs eventually gave rise to a work. "To tear" functioned as the rule behind *Tearing*, an eight-foot square of lead sheet, its corners shorn into frayed lanyards that exfoliate over the studio floor. Then, in 1971, "to drop" triggered the short film *Hand Catching Lead*. This recourse to language is unusual for Serra, whose commitment to the medium of sculpture is focused on the nexus between the visual and the material fields, or the consequences of the fact that we are physical bodies with eyes riding atop a mobile premonitory, like caliphs astride ceremonial camels.[26]

The rules understood by Ruscha, Coleman, Kentridge, and Serra are not these conceptualist shards of language standing apart from their process and their materials, but deeply embedded in the complex of their work's support, obvious to the viewer of that work.

T̲iger's leap — *The medium as latency*

Walter Benjamin sees history as *anything but* empty, frozen time. It is, for him, the structure of latency. Something is lying in wait for the historical actor to which he will be instantly snatched back in time, as though by a tiger's leap (*Tigersprung*).[27] Rome was waiting for Robespierre, Benjamin writes, to provide a décor for the Revolution. Stain painting was waiting for Ed Ruscha to give him solace from the oil on canvas that had failed him.

Tells the truth — *Myself, on the road*

Wednesday, March 17—The spring of 1999, several months pre-aneurysm, found me in London, giving a lecture at the National Gallery in honor of Walter Neurath, the founder and publisher of Thames & Hudson. Unsurprisingly, in the light of my current convictions, my topic was what I called the "post-medium condition," in a statement of what I hoped was a convincing and impassioned argument against its poverty. Early the next morning I flew to Barcelona, to work at MACBA on a projected exhibition to be called "Sign Elsewhere."[28] The exhibition was planned to deal with the way that, from cubist collage to Jasper Johns, the written signifier had appropriated the surface of modern art. As it happened, MACBA was then hosting a brilliant retrospective of the films of William Kentridge, making my respites from work the pure pleasure of getting to know his art.

It was at the moment in *Ubu Tells the Truth* when the police building—from which the prisoners plunge, in the gate-of-the-projector sequence—is represented as a grid of light squares on dark (in a constellation of luminous windows) which serve as repetitive images of the film frames themselves, that Kentridge's work exploded for me into the full power of its modernism. With this reflexive presentation of the cinematic medium, I encountered one more example of "perspicuous representation," and I immediately enrolled Kentridge as another of my knights in the service of the medium.

Ulysses — *"Dublin, Georgia was another town . . ."*

Saturday, October 5—I leave Paris in the bright sunlight of the early autumn of 1996, my copy of *Ulysses* unfolded on my tray table. I am looking out the window as Cork passes below me, on my way to Dublin. I am going to visit James Coleman so I can write an essay for the catalog of his next exhibition. I will stay the several days necessary to see his work. This is my fourth entry into Bloom's world. At each reading I come to grief at about page 100. This time I hope to vanquish the book, buoyed by the very landmarks of Bloom's

and Stephen's passage through the city. The complexity of my task makes immersion in Joyce's universe more urgent. Coleman's Ireland is a world I know nothing about, and perhaps *Ulysses* will be my guide to what Joyce calls "Sireland."

Coleman, who meets me at the airport, shows himself all too happy to be my escort. He drives me through Dublin showing all the development that membership in "Europe" has made possible for Ireland. It occurs to me that this wealth might bring a resolution to the "troubles," the struggle between North and South suspended by a plethora of jobs and new opportunity.

We drive along the River Liffey and then turn north to reach Coleman's studio in Mountjoy Square. In *Ulysses*, Joyce has Father Conmee walk along the Square to greet the wife of the absentee landlord of one of these elegant, Georgian townhouses. For the next four days I will occupy the parlors of the rented townhouse where Coleman has improvised a ground-floor screening room, projecting his multiple beams of light onto the far wall of the second parlor through the opening of the connecting arch. I am seated next to a makeshift lamp, veiled to prevent any luminous spill but providing enough light for me to take the necessary notes and make my little drawings. Coleman will allow no version of his work to circulate aside from the carefully orchestrated display of the "original." To remember its complex interaction between image and language, I need to make rapid little sketches and frantic indications of the issues I think are at work. Coleman's version of the slide tapes he has made the technical support of his art combines at least two converging projectors focused on the same point of the screen so that the image radiates a dazzling density of information, its colors brilliantly clear and deep, its volumes burgeoning into sharp relief. A computer controls the advances of the slides and also the focal length of the projectors' lenses so that, with changes of focus, the relation between parts of the image can be adjusted to the look of cinematic effects such as fade-in, fade-out, or dissolve. The computer also controls the taped soundtrack, with its piping voice-over narrative, giving life and direction to the characters in the images.

I have come prepared by reading all the critical essays I can find on Coleman, a slender batch since his work is little known and his importance underrecognized. The current enthusiasm for "postcolonial studies" and for "postnational identity" has drawn various critics to this Irish artist, hoping to find in his work a polemic against the idea of a mainstream modernist

Figure 2.22
James Coleman's studio in Dublin.
© James Coleman.

aesthetic forged in Western Europe and America. This is the very polemic welcomed by Catherine David. The "identitarian" reading of Coleman is programmed by poststructuralism's doctrine that subjectivity is not innate but, rather, constructed out of the *bric-à-brac* of cultural stereotypes, whether visual or auditory. According to this dogma, we grow into selfhood by identifying with the positions our language and our native field of visual imagery make available to us. "Postcolonial studies" focuses on the dilemma posed by these stereotypes, which the colonized must simultaneously reject as the patronizing straitjacket of their foreign masters but, paradoxically, adopt as the only means they have to construct their own, national tradition—a basis of cultural independence, no matter how stereotyped.[29] While the Abbey Theater and the Irish literary renewal were determined to avoid the "stage Irishman," their plays nonetheless needed to invoke characteristic Irish behavior to be intelligible to their audiences.

ReVivals — *Wild swans at Coole*

The Abbey Theater was founded in 1904 by Lady Augusta Gregory and William Butler Yeats, the culmination of their combined efforts to support the vigorous literary revival in Ireland. The Gaelic League of this revival often assembled at Coole Park, Lady Gregory's estate. On one such occasion they sealed their collective dedication to their cause by carving their initials into a beech tree in Coole Park: W. B. Y[eats], G. B. S[haw], J. M. S[ynge], S. O['Casey], O. W[ilde], J. J[oyce]. Since that time, visitors to the Park (now famous from Yeats's poem "The Wild Swans at Coole") have viewed these historic carvings as exemplary graffiti. Indifferent, they have vandalized the tree by carving their own initials into the bark, undeterred even by the tree's protective fencing. Coleman's *I N I T I A L S* invokes this near its beginning. The text connects the letters of its title with the historic union: "It's hard to make out the initials on the skin of the autograph tree. / It's hard—it's hard to make out the initials, the initials growing still."

Sunday, October 6—When we break for lunch we mount to the fifteen-foot-high parlor floor studio where stately windows overlook the Square and ornate stucco cornices mark the eighteenth-century construction of a Geor-

gian house that is nearly identical to the James Joyce museum. There A. J., Coleman's son, has assembled the breads, cheeses, and fruit of our repast and I am free to examine the storyboards for *I N I T I A L S* Coleman has left in evidence. It is possible for me to eavesdrop on the directions he gave his actors so that the character of their gestures would radiate the ambience of the sentimental novels on which his conception of the work was based. Under the scene of the two central personages, the tubercular patient and the nurse-technician who is reporting on his examination, Coleman has prompted (copying his text from the trashy Hills and Boon nurse-and-doctor "romance" novels):

> His eyes darkened and met hers so deliberately that she lowered her gaze as she said "Nevertheless there are periods of stability even in the most turbulent relationships. People manage to achieve harmony for a life time."

> A touch of bitterness sharpened his voice. "They're singularly fortunate." Then, as though he had no intention of continuing the conversation, he added, "Now I must get back to work; thank you for putting me in the picture and for handling the case so well."

> DA[ndy] I *swear* . . . you look (a smile) *I* feel (happy?)

. . . **W**hy do you . . . ? — *The medium is self-reference*

Despite *I N I T I A L S*'s obvious invocation of Irish literary intensity, I refuse to embrace the Irish identitarian reading as accounting for the work's considerable power. Rather, it seems to me, the work refuses to let go of the sides of the white cube and the force it can get from that point of resistance. The reedy, child's voice that pronounces the script often breaks into the flow of words with the sound of hyperventilation, the deep breaths that accompany the serious passages of spelling various words in the script: U N F O L D E D and C O N D U I T S. The rapping sound of the individual letters and their dispersion into unintelligibility again makes reference, I think, to the apparatus of Coleman's projections: to the click of the slides falling into place and the motion of the carrousels, an apparatus that likewise disperses the visual

flow of the image field. Specificity is thus a concern of Coleman's as he builds the complex structures of his "projected images." The frequent and intrusive use of the double face-out to acknowledge the distance separating his apparatus from that of film, with its access to angle/reverse angle editing, is another instance of Coleman's concern to think through the conditions specific to the medium he is both exploring and inventing.

As Coleman displayed the works he had made in the medium he refers to as "projected images," these reaffirmed my convictions about his allegiance to a medium and its very specificity. This helped me think of Coleman as another knight in the service of the medium. On my return to Paris my problem became one of finding and articulating the rules of this *automatism*. In this endeavor, Coleman's work supplied its own helpful resource. The script of *I N I T I A L S*, lifting passages from Yeats's play *The Dreaming of the Bones*, quotes the narrator asking the two fleeing lovers: "Why do you gaze, one on the other . . . and then turn away?"—the perfect, self-aware description of Coleman's rule of the double face-out.

Fau X marbre — *Portrait of the artist as a young man*

Monday, October 7—Coleman is preparing me to write on his art by giving me a retrospective of its development, beginning with the work he made in Italy at the outset of his career. Two of the earliest he could show me are films: the first a fixed frame trained on a window looking out onto the woods and fields of a country house. The flies, frantically hurling themselves against its pane, are trying to escape the interior of the house while the camera records their urgent, hapless flight. Crawling and colliding, their movement materializes the film's screen otherwise dissolved into a luminous haze. Like structuralist cinema, then, *Fly* kicks off against a part of the filmic apparatus. This is also true of *Pump*, in which the camera fixes on the white interior of a bucket, which slowly fills with the water flowing from the spigot of a black pump placed above it. Initially, the water obscures the bottom of the bucket, covering it over by its foaming entry into the container. But as the level of the water rises, it becomes more and more transparent, so that once the bucket is full its interior is as fully visible as it was at the beginning. The volume of water

is, then, like the camera's lens, a transparent medium through which we look, one made curiously visible by the movement of film and water. To make the lens itself visible is to follow the rule of structuralist film.[30]

Back in my hotel I think about this introduction against the background of what I've read about Coleman. Most of his critics pour his work through the grid of poststructuralism's theorization of the construction of the subject, a deconstructive theory that contemptuously dismisses all essentialist ideas (the *who* of "who-you-are"). Here is Michael Newman from the essay "Allegories of the Subject: The Theme of Identity in the Work of James Coleman":

> It is a central premise of this essay that "subjectivity" is not an essence which is the property or possession of the individual, which remains constant and which is expressed by actions or works of art; but that the individual human subject is constituted in the positions offered by representation and discourse.[31]

In searching for the bedrock of its medium, however, structuralist film thumbs its nose at the idea of antiessentialism, deconstruction's scorn for "self-presence," or Kha-tee's censure of "ontological difference." Instead the movement embraces essentialism, believing that every part of the apparatus is such a constant material fact that it cannot be continually "reconstituted" by the viewer of the film.

I think about this in the light of the materials Coleman had unearthed to show me after last evening's supper, particularly the painted copy he had done during a visit to the Louvre. Having set up his easel in the Renaissance gallery, he proceeded laboriously to copy the marble veining painted onto the gallery walls as a sumptuous, seventeenth-century fiction. His reproduction complete, he submitted it to the official who had to stamp it on the reverse side in order for him to take it out of the Museum. At first the administrator refused to certify the canvas, saying that since it was not the imitation of a work, it could not be said to be an official copy. But, Coleman reasoned, since it was a copy of a painted passage on the walls of the Louvre there was no reason why it couldn't qualify for certification. At last the official relented and Coleman left with his brilliant canvas of *faux marbre*.

Fake marble has nothing essentialist about it. But Coleman's interest in the Louvre's walls had zeroed in on their "support" for the works of art.

Nothing concerned him so much as this material background, the very sides of the pool against which each artist's work has to kick. With *Fly*, *Pump*, and the *faux marbre* canvas in my head, I realized that the whole discourse on the social construction of the subject was so much fashionable, theoretical twaddle that could not engage the ambitions of Coleman's project. These ambitions, I concluded, were concerted to find a way back to modernism, not by embracing exhausted mediums, like painting or sculpture, but by inventing a new medium, the way Ruscha had drafted the car into service.

You daft — *Fortuna*

If *Ubu Tells the Truth* was my breakthrough to a sense of Kentridge's thrust off the side of the pool, both *Monument* and *Mine* developed this conviction through their "perspicuous representation" of Kentridge's own process. *Monument*, based on the Beckett play *Catastrophe*, depicts a South African slave perched on a pedestal, his heavy bundle on his back. In the Beckett play, a director is crafting his final image by sending his assistant out to stage center to adjust the costume and makeup of the immobile figure poised before his imagined audience. As the director barks his orders from the wings, the assistant carries these out bit by bit, each time returning to join him offstage. Kentridge's films are produced by just this shuttling back and forth across his studio from his camera to the drawing on its easel, which he erases in order to modify its contours slightly. After this he shifts back to his camera to expose one frame of the altered image. It is by projecting the sequence of these frames that the illusion of movement is produced. This oscillation between camera and easel, fundamental to his process, Kentridge himself calls "stalking the drawing."

Mine is the presentation of the mine owner Soho Eckstein lying in bed having breakfast while, from the depths of the cavern below him, a whole world of African treasure is sent up the mineshaft onto his coverlets. The lecture "*Fortuna*: Neither Program nor Chance in the Making of Images," which Kentridge wrote to share with his listeners the details of making this film, recounts his dilemma at the outset of the film over how to get Soho out of bed and into his office to engage in the running of his industrial empire. Having rung for his breakfast, Soho needed a coffee pot on the tray placed before him. It was

then that a happy chance (*fortuna*)—something Kentridge came across as he wandered in his studio—not only solved the local problem but provided the armature for the film as a whole.

He stresses the improvisational character of his discovery, along with the fact that he came upon it on the prowl: "What was going on while I was in the kitchen preparing something to drink? Was there some part of me saying 'Not the tea, there, you fool, the coffee, not espresso, the cafetière, you daft . . . Trust me. I know what I'm doing.' If I'd had tea that morning, would the impasse of Soho in bed have continued?"[32]

Having found what he calls a "cafetière"—the kind of pot that is a glass cylinder with a plunger to compress the grains of coffee—Kentridge recounts: "It was only when the plunger was half way down, in the activity of drawing, erasing it, repositioning it a few millimeters lower each time, that I saw, I knew, I realized (I cannot pin an exact word on it) that it would go through the tray, through the bed and become the mine shaft" (68). And in this becoming, the whole of the film opened up for him. The meaning of the relationship between the mine and the bed, in which Soho will be seen "excavating from the earth an entire social and eco history," became apparent to him; "Atlantic slave ships, Ife royal heads, and finally a miniature rhinoceros, are all dragged up through the shaft embedded in the rocks to Soho having his morning coffee" (60).

Fortuna is Kentridge's word for chance and the luck of seizing it rather than letting it go: "The sensation was more of discovery than invention. There was no feeling of what a good idea I had had, rather, relief at not having overlooked what was in front of me." That his prowl through the kitchen forms a parallel for him with his very process of "stalking the drawing" echoes in his remark: "It is only when physically engaged on a drawing that ideas start to emerge. There is a combination between drawing and seeing, between making and assessing that provokes a part of my mind that otherwise is closed off" (68).

Importantly, Kentridge's *fortuna* runs parallel to Cavell's *automatism*. The necessity Cavell feels to jettison the word *medium* and to mark that discard with the lexical complexity of *automatism* registers his dismay over what he calls "the fate of modernist art," a fate that led the arts to a brute reductivism as if the mere listing of the physical facts of a work's support—the flatness of its canvas or panel, the volumetric independence of the block from which it is carved—were the same as a struggle to wrest significance from these very

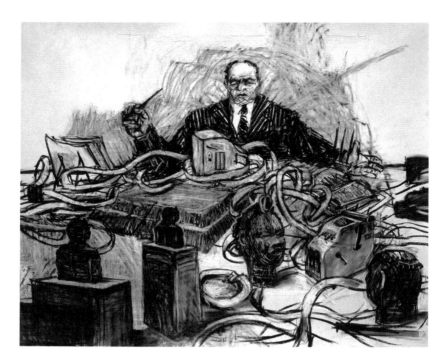

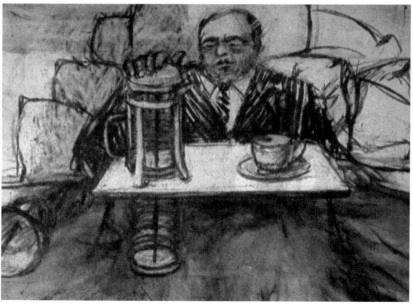

facts. As we have seen, Cavell condemns this brute empiricism as having so limited modernist art "that its awareness and responsibility for the physical basis of its art compel it at once to assert and deny the control of its art by that basis." *Automatism* is used along with *medium*, Cavell explains, as a way of both acknowledging and resisting that fate: "This is also why, although I am trying to free the idea of a medium from its confinement in referring to the physical bases of various arts, I go on using the same word to name those bases as well as to characterize modes of achievement within the arts."[33]

Arguing that the problem now posed by modernism is that the job its artists are asked to undertake "is no longer to produce another instance of an art but a new medium within it," Cavell alternatively describes this concern as "the task of establishing a new automatism," so that "at no point are we or the performer in doubt about our location or goal." *Automatism* allows Cavell to circumvent the merely mechanical or empiricist associations of the word *medium*, limited to the brute, physical character of a work's material support. Kentridge's *fortuna* rhymes with Cavell's idea of improvisation's re-lease of spontaneity. The knight moves by rule: two squares ahead or behind, one square immediately to left or right, or vice versa. Its freedom is that it can jump over intervening enemy pieces, but its rule ensures its reference to the support of the chessboard which it cannot help but figure forth.

99

Figures 2.23, 2.24
William Kentridge, drawings from *Mine*, 1991.
Courtesy of the artist and Marian Goodman
Gallery, New York/Paris.

three
THE KNIGHT'S MOVE

There are many reasons for the peculiarity of the knight's move, of which the first is the convention of art. . . . The second reason is that the knight is not free: it moves on the diagonal because the direct road is forbidden it.
—Viktor Shklovsky, *Knight's Move*[1]

The grid has been one kind of the "convention" Shklovsky mentions. It has endured throughout the modern era—one of the recursive structures by which artist after artist (Picasso Mondrian Malevich) secures the "luminous concreteness" of his canvas. Shklovsky is the best writer on the conventions of art. A Russian formalist, he lies in wait for what he calls the "devices" that a great work will "lay bare."[2] Sometimes he calls this move "motivating the device." The device is the recursive formal ruse that "points" to the work's source of aesthetic pleasure. For Shklovsky it may be a turn of plot in a story that

"bares the device."[3] Does the windshield wiper on Soho's car reveal the "device" of Kentridge's erasures? The narrative of the ride in the rain "motivates the device." Are two adversaries playing chess, as Nabokov relates in *The Real Life of Sebastian Knight*? This opens the story to the chessboard's narrative substitution for the grid as pictorial "device." Hubert Damisch focuses on the chessboard as so many checkered pavements—black marble square against white—in the cathedrals and palaces of the Renaissance. It was their geometric grids that ruled off the space later rationalized as perspective.[4]

So many chessboards. It is the chessboard that controls the knight, limiting his freedom, reining him, as Shklovsky says, to the "conventions of art."

The knights of Shklovsky's moves are formalism's crusaders. They traverse the board according to its rules. They cannot invent the rules but only obey them. This makes the board and its conventions the *technical support* of chess. My knights of the medium are like Shklovsky's; they are in search of *technical supports* so as to extend the life of the medium.

Skillful use of knights is the mark of the professional player.

Shklovky was a "professional player," excavating the formal devices beneath the "event" that motivates it. In this, Gertrude Stein would have named Shklovsky a *genius*. "What is a genius. Picasso and I used to talk about that a lot. Really inside you if you are a genius there is nothing inside you that makes you really different to your inside you than those are to themselves inside them who are not a genius. That is so."[5] Critics, like formalists, can make themselves professional players, if not geniuses. They keep their ears to the ground, listening to the surface of the chessboard for the hoofs of the advancing knight.

Christian Marclay is a knight of the medium, exploring the technical support of the synchronous sound that turned movies into talkies. Marclay's *Video Quartet* spreads four DVD screens across forty feet of wall, to form a horizontal frieze crossed by the four vertical axes of unreeling compilations of clips from famous movies, each column a continuous spool of film. Often the horizontal array repeats a given form, as when each of the four screens bears a circle—a record on a turntable rhyming, for instance, with a group of drumheads, themselves rhyming with a spinning roulette wheel: the circles

here motivate the "device," by "imaging forth" the reels of film itself. The vertical axis is less formal than temporal, a stunning moment occurring when the leftmost screen swells with a clip of cockroaches scurrying soundlessly over a piano keyboard. Here the temporal drive reverses itself, as we imagine history reeling backward to 1929 and the eruption of synchronous sound into the silence of early film. The sensation is one of actually *seeing* the silence, as though we could see the invisible audiotape crusting the edge of the strip of film to give it a track of sound. Silence is often pictured, as *Video Quartet* opens with orchestral scores propped on music stands, or the bare feet of an organist working the peddles.

Synchrony is also pictured, as one clip confronts us with the gang from *West Side Story* snapping their fingers in percussive, threatening unison. Marilyn Monroe from *Gentlemen Prefer Blonds* furls her fan shut with a percussive click exactly timed with the identical sound as a geisha snaps her own fan closed on the neighboring screen. If the "device" is synchronous sound, it is "motivated" by silence. Silence and sound can be said to be the binary for the paradigm of /speech/. It was speech that converted the movies into talkies. With the images from *Video Quartet*, Marclay's knighthood emerges as the decision to make synchronous sound into the technical support for his invented medium.

The pattern has been revised. The knight is the most important piece on the board.

The "pattern" of modernism is thought to be teleological: a relentless one-way drive toward the logical reduction of a given medium to its essence, each stage of this reduction outmoding and supplanting its predecessor. Hence Joseph Kosuth's certainty that art must essentialize itself as a bare statement of self-definition, or minimalism's declaration that painting reduced to flatness is nothing but an ordinary object. The knights defy that certainty by projecting the logic of the medium back onto the very onset of this forward march, feeling free to remember the earlier history of their own medium.

With his aimless cockroaches, Marclay turns the clock back to the advent of synch sound; or, when his *Stains* open onto the color field experiments of the 1960s, Ruscha evokes the history that called for the advent of

103

Figure 3.1
Christian Marclay, still image from *Video Quartet*, 2002. Four-channel DVD projection, with sound, running time 14 minutes, each screen 8 × 10 feet; overall installation 8 × 40 feet. © Christian Marclay. Courtesy Paula Cooper Gallery, New York.

"stain painting"; or, when Broodthaers alternates his details of the marine landscape in *L'analyse d'un tableau* with blank screens given "page numbers" as their intertitles, the details of the seascape leap from Manet's beginnings of modernist painting or Courbet's waves to a climax in the monochrome, the "pages" here suggesting an art history book, the very destiny of art that André Malraux called the "museum without walls."

Knights can pass over squares controlled by enemy forces. Knights always end their move on a square of the opposite color.

Jacques Lacan wasn't speaking of knights when he wrote of the "preeminence of the signifier over the subject." Lacan's "Seminar on 'The Purloined Letter'" meditates on the alphabetic letter's (the signifier's) dominance over its possessor. Structuralism understands alphabetic letters as signifiers, which it pairs into opposites, or paradigms: M[en] versus W[omen] producing the paradigm for gender.

W is for Woman — *The dominance of the letter over the subject*

The opposite colors of the knight's move articulate the paradigm Lacan develops in "The Agency of the Letter in the Unconscious." That essay's letter is an alphabetic signifier made explicit in its diagram of public lavatory doors labeled by gender, the diagram dividing humankind into two classes so that, entering one door or another as they are bidden, they pass through the channels of what Lacan calls "the defiles of the signifier."[6] In his "Seminar on 'The Purloined Letter'" Lacan intentionally plays on the double meaning of *letter*: the first, or alphabetic, signifier of the unconscious submitting the subject to its dominance, while in the second sense the letter is a missive, stolen and circulating from one character to another in Edgar Allan Poe's story "The Purloined Letter." According to the law of the letter's "preeminence over the subject," the letter-as-unconscious will dominate any subject who holds

the actual letter of the tale, no matter how briefly, transforming the male possessor's actions into those of a woman.[7]

"The Purloined Letter" tells the story of an actual letter circulating between male and female characters, as the Queen in her boudoir, disturbed by the entrance of the King, puts a letter she is reading face-down on her dressing table. The Minister who enters, seeing the letter's written address, picks it up and carries it off before the Queen's very eyes. Wishing to hide it until the propitious moment comes to use it against her, he hangs it face-in, address side up, on the card rack in his apartment. In Lacan's analysis this physical letter has transformed the possessor from active male to the passive female of the Queen, as the Minister, failing to act on the letter, gradually forgets it. "So the Minister," writes Lacan, "by not making use of the letter, comes to forget it. This is expressed by the persistence of his conduct. But the letter, no more than the neurotic's unconscious, does not forget him. It forgets him so little that it transforms him more and more into the image of her who offered it to his discovery, so that he now will surrender it, following her example, to a similar discovery."[8]

This second capture is the act of the sleuth Dupin, who—like the analyst—will know, even beforehand, where to look for the letter: it will be a mirror image of the Queen's and in the same position. The rest of the story unfolds Dupin's theft of the letter held by the (feminized) Minister, the letter-as-signifier having "dominated" him as subject.

W indow is for painting — *But the letter does not forget him*

Almost from the first, painters imagined piercing the "luminous concreteness" of the canvas by likening it to a window, the view both opening the picture surface and returning depth to its plane. After the invention of perspective, the window frame came to be the signifier of painting itself.

The interdependence between painting's specificity and the white cube derives in part from the resistance of the gallery wall but also from the rectilinear shape of the room as a support for the picture and its oblong frame. This framing shape is so determinant for the picture's identity that it might be

called the signifier of the presence of painting, as in Lacan's psychoanalytical consideration of letter and subject.

Like Poe's Minister, the installation artists' decisions are determined by the letter of *painting*, which, so long as they assume the role of artist, never forgets them. To register their claims, the installation artists assemble their items of display in those spaces marked by the institution of art as versions of the white cube: museums, galleries, art fairs. And then, like the neurotic suffering from the return of the repressed, they produce the phantasm of the very medium they are determined to forget.

Again and again Rebecca Horn—canny master of installation—summons forth the pictorial letter. *Book of Ashes* (1985), a shallow black pool floated on the floor of the gallery, recalls the whole history of monochrome painting, like the white sail of Broodthaers's *L'analyse d'un tableau*. Then, in *High Moon* (1991), two rifles hang from the gallery ceiling, the vertical cords of their suspension joining with their facing barrels to outline a rectangular "frame" on the gallery wall behind them. The "moon" that rises within this space glows, then, with the reflected light of the pictorial letter.

A knight can be used to threaten two widely spaced units simultaneously. (This is called a "fork.") If one of these threats is against a king the other piece must inevitably be lost.

Sophie Calle's technical support is adapted from the newspaper's genre of investigative journalism. Like Woodward and Bernstein unraveling the Watergate enigma, Calle uses the interviews of all subsidiary witnesses to construct the identity of a mysterious, absent center. The newspaper format of text plus photograph is, indeed, her model. An instance is Calle's finding the lost address book of an owner she assumes to be a man and calling all the telephone numbers in the register to interview those persons about the book's absent owner. These interviews were published daily in *Libération*, thus "figuring forth" for the newspaper's readers her very technical support. As journalism's story unfolds from day to day, the writer has no idea of its ending and thus has no advantage over the reader. This loss of control might highlight the

"empty center" of the piece, the character the investigator stalks with her photographic documents as the indexes she precipitates off of reality itself. Calle's technique attracted the attention of the novelist Paul Auster, who made her a character in his book *Leviathan*. Imitating her devices, Auster sets out to find his dead friend, Benjamin, by interviewing the latter's associates to construct a picture of Benjamin's life. As André Breton demonstrated in *Nadja*, the photographic novel can, like the journalist's story, circle back to index the subject himself as a trace of the real.[9] Breton lards his novel with photographs taken, as he explains, from the point of view from which he himself experienced the places through which he had wandered with Nadja.

This use of the index to perforate the subject of the artist herself occurs in Calle's 2002 *Take Care of Yourself*, a work commissioned by the Ministry of Culture for France's pavilion at the 2007 Venice Biennale. In 2008 the work was installed in the reading room of the Bibliothèque Nationale in Paris. A series of video monitors each projected a performer (some actresses such as Jeanne Moreau and Miranda Richardson) reading the letter sent to Calle by a lover sadistically rupturing their affair and hypocritically signing off, "take care of yourself." The work assumed its position in Paris amid the book-lined walls of the library's reading room. A repeated exercise in "reading," the march of Calle's monitors along the tables engaged the space as though it were installation art. But each performance of the letter returns the visitor to Calle's own *support*, both in her touching base with the bookshelves as the sides of her cube and in her implication of investigative journalism in an attempt to find the identity of the letter's writer as an unknown Other.

Figure 3.2
Rebecca Horn, *Book of Ashes*, 2002. Steel, mirror, carbon, gold leaf, mechanical structure, ashes, cello, 2 cello bows, mechanical structure and sound, installation dimensions variable, mirror 100 × 71 × 4 in. (254 × 180 × 10 cm), mechanical stylus 168 in. (427 cm), cello 52½ × 31 × 43 in. (133 × 79 × 109 cm). Photograph: Attilio Maranzano, © Rebecca Horn. Courtesy Sean Kelly Gallery, New York. © 2010 Artists Rights Society (ARS), New York/VG Bild-Kunst, Bonn.

Figure 3.3
Rebecca Horn, *High Moon*, 1991. Two Winchester rifles, glass funnels, circular saw, red paint, pumping machine, metal construction, electronics, motors, dimensions variable. Photograph: Jon and Anne Abbott, © Rebecca Horn. Courtesy Sean Kelly Gallery, New York. © 2010 Artists Rights Society (ARS), New York/VG Bild-Kunst, Bonn.

Figure 3.4
Sophie Calle, *The Address Book*, 2009. Portfolio of 28 prints in screen-printed binder, with 3 related prints, 15¼ × 12⅝ in. © 2010 Artists Rights Society (ARS), New York/ADAGP, Paris.

It is only when the visitor realizes that this "other" is probably Calle herself that the idea of installation collapses—caught in a fork—rendered specific to Calle's individual medium, which is not the room but the search for the index of the real to which she as its subject is lashed.

The knight does not so much combat installation as ignore it—simply jumping over the squares controlled either by it or by conceptualism. Landing on the opposite color, it reopens the historical a priori of the specific medium. The Berlin artist Harun Farocki's *Interface* holds installation in a fork as well, pushing off the sides of the pool, making them perspicuous.

Farocki's fork

Farocki is always referred to as *filmmaker* and his art as *installation*.[10] Indeed, in museum exhibitions, a bench is provided for the viewer to watch the work unfolding before her on two video monitors, elevated to eye level by individual pedestals and positioned side by side. As opposed to video installations by artists such as Bill Viola, in which the viewer is embraced by the video surround, the distance from bench to monitor here objectifies the work, allowing the critical reflection essential to aesthetic experience.[11] Sometimes the images on the neighboring screens narratively relate to each other, so that the viewer finds her eyes transiting from side to side. In *Interface*, this narrative succession compares a typewriter to a diagram of the rotors in the famous Enigma, the machine the Nazis used to encrypt secrets definitively before

Figure 3.5
Sophie Calle, installation view of *Take Care of Yourself*, Bibliothèque Nationale de France, Paris, 2008. © Sophie Calle. Courtesy Galerie Perrotin, Paris, and Paula Cooper Gallery, New York.
© 2010 Artists Rights Society (ARS), New York/ ADAGP, Paris.

transmission during World War II. During this sequence, Farocki speaks of the British efforts at Bletchley Park to find a way to decrypt Enigma's code. In *Interface*, Farocki lingers in his video editing room displaying its equipment. (As his workplace for processing images and sounds, video editing needs *console de réglage* [control deck] and *magnétoscope* [tape deck] for recording.) We are arrested by the mirror between the pedestals in the gallery and the studio: each with two images to view simultaneously—one screen relative to another. Farocki underscores the importance of the double screens both for himself and for the eventual viewer. "Today I can hardly write a word," he says, "if there isn't an image on the screen at the same time. Actually, on both screens." Farocki explains his process by mentioning how long a section of tape he copies from the raw footage before inserting that two-minute segment into the developing film.

Analog images from the film are transposed by computer programs such as AVID into the digital information of the video screen. The digitally registered tape will leave no traces of this intermittence, for unlike the splices of a filmstrip, Farocki shows us, the insertions are not perceptible by touch. Like the double monitors at which we are looking when seated in the museum, the video process also requires the editor to study the information on two monitors at once, the one with raw film, the second with already edited sequences into which segments from the first will be copied. But beyond the editing room's mirror of the work's apparatus, it is the passage of the viewer's gaze from monitor to monitor that causes the eye to slide over the wall of the museum in its inquisitive transit. The eye thus hits the "side of the pool," making the image's visual support—or its containing ground—perspicuous. Farocki's use of the video editing room, as echo of the pedestals in the museum, grounds the presentation itself in what has to be called its "technical support." The double doubled as Farocki's celebration of specificity is enrolled as medium—the double of the knight's fork—holding installation's king in check. As knight of the editing room, he says "check" to installation art's demand for an end to the medium, as to the white cube. His work may be called installation, but it circumvents it.

Bill Viola vaporizes the white cube's sides of the pool with the constant blue aura of the projected image—the mist of our imaginations and our dreams. Television is the background of our drift off to sleep, not the percussive wall awakened between the pedestals of *Interface*.

Figure 3.6
Harun Farocki, stills from *Interface*, 1995. Courtesy
Harun Farocki Filmproduktion.

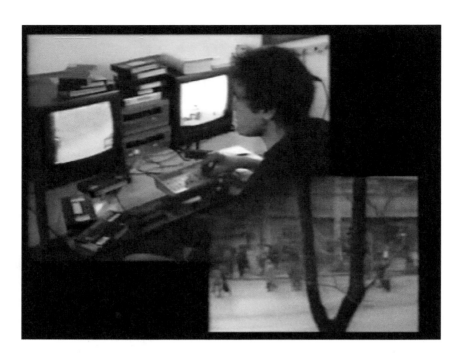

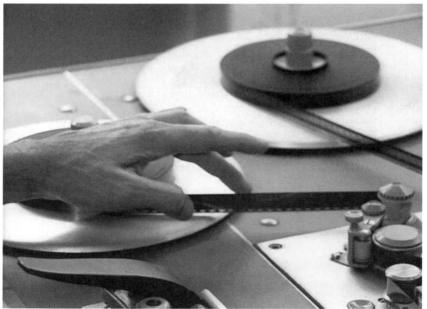

Figure 3.7
Harun Farocki, stills from *Interface*, 1995. Courtesy
Harun Farocki Filmproduktion.

Figure 3.8
Harun Farocki, installation view of *Interface* in
"One Image Doesn't Take the Place of the Previous
One," Leonard & Bina Ellen Art Gallery,
Concordia University, Montreal, 2007. Courtesy
Harun Farocki Filmproduktion. Photo © 2007
Richard-Max Trembley.

Video promenades — *Nauman taking architecture for a walk*

Within the development of modern architecture, one of the problems posed by larger and larger buildings was that of circulation: how to move ever greater numbers of people through the taller and longer spaces of skyscrapers, shopping malls, and giant hotels while making such trajectories pleasantly habitable and not disorienting to their milling crowds. Gradually, architects made circulation itself into an autonomous form—think of Frank Lloyd Wright's solution to the Guggenheim Museum where the spiral ramp-as-pure-circulation is also the space of exhibition, the advantage of combining the two being the phenomenological payoff that from the moment one moves onto the ramp one can see the endpoint of the trajectory, so that circulation and its goal are combined with brilliant efficiency. All the ramps and spiral staircases of modernist architecture—Le Corbusier has to be included here—have this drive behind them, and the term used by archi-speak to mark the autonomously conceived axis of circulation was *promenade*. *Promenade* signaled the independent-focus-of-the-design as the specificity of architecture itself. In his early videos, Nauman recorded his search for an idea by showing himself "Bouncing in a Corner" or "Turning Upside-down." Such pacing within his studio was, I realize, a form of *promenade*. The corridors he devised to mark this activity were continuous, then, with the most modernist and highest forms of architecture. But with the video monitors added to them, they descended from the heights of *promenade* to the depths of surveillance—becoming the anti-architecture of the merely anonymous hallways of office buildings or apartment complexes, within which televisual security measures are on constant alert.

By 1986 and Nauman's work *Violent Incident*, the bank of monitors, through which the viewer oversees the onset and development of the altercation between two characters who eventually shoot one another, switches one's perspective from being the object monitored in the apartment corridors to that of the subject of surveillance; that is, from watched to watcher. And with this switch, Nauman seemed to have entered the uncertain terrain of locating the specificity of video as a medium.

Not only had video no specificity as an aesthetic support, but it also seemed to void the whole modernist project of keying the meaning of a work to the revelation of the specific nature of its material form. This conceptual

lacuna attracted attention during the '60s and '70s as critics and theorists took up the problem of video's elusive essence.

Fred Jameson's response was to deal video into the dominant aesthetic form of late capital, which for him was postmodernism. Adopting Raymond Williams's designation for television ("total flow"), Jameson was intent as well to characterize the internal workings and structures of such continuous but uninflected sensory stimulation, a continuousness most theorists simply reduced to the epithet "boredom."[12]

Postmodernism, Jameson retorts, is not boring. Rather, it generates the stimulating form of a constant sampling of tiny quotations, each of which beams the signal of a narrative as a kind of emblem or logo—the looming monolith in the landscape, for example, announcing in a flash the whole unfolding of Kubrick's *2001*. Postmodernism is a collage of such fragmentary quotes, each become a signifier without any referent in the field of the Real. If video is the exemplary medium of postmodernism, Jameson concludes, it is because it has the capacity to stage such ceaseless reshuffling of the fragments of preexistent texts.

For Stanley Cavell television is also essentialized around the idea of "total flow." He renames this, however, calling it "a current of simultaneous event reception."[13] Such a current, he argues, is not perceived through what we ordinarily understand as viewing, but rather through the more passive activity of monitoring. It is surveillance, then, that essentializes television's technical support in video. Nauman's activity in video has consistently developed within the terms of this argument, although I am sure it is not an analysis with which he is familiar. I would say instead that he was instinctively attracted to the ubiquitously placed surveillance monitors and this is why he used them consistently in his video corridors and in the later work *Mapping the Studio*.

Since neither surveillance nor total flow captures the essence of video, I turn to yet another theorization of this medium so resistant to notions of essence. This is Sam Weber's brilliant essay "Television: Set and Screen," which engages less with artists' video than it does with broadcast television. Weber moves in on the question of ontology by refusing it on the grounds that one must always respect what he calls television's "constitutive heterogeneity." Television's defining condition, he argues, is difference. It is different from film, as well as being different from what is generally known as visual perception. "Above all," he concludes, "television differs from itself."[14] This

Figure 3.9
Bruce Nauman, *Live-Taped Video Corridor*,
1970. Wallboard, video camera, 2 video monitors,
videotape player, videotape, 144 × 384 × 20 in.
(365.8 × 975.4 × 50.8 cm). Solomon R.
Guggenheim Museum, New York. Panza
Collection. Courtesy Sperone Westwater, New
York. © 2010 Bruce Nauman / Artists Rights
Society (ARS), New York.

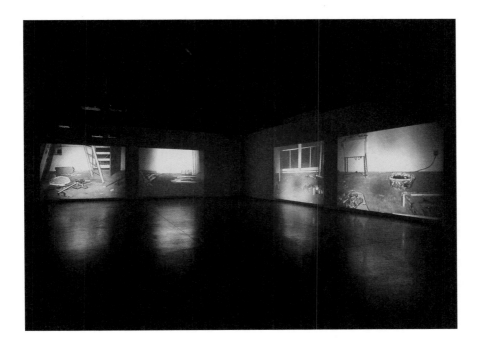

Figure 3.10
Bruce Nauman, *Mapping the Studio I (Fat Chance John Cage)*, 2001. 7 DVDs, 7 DVD players, 7 projectors, 7 pairs of speakers, 7 log books, 05:45:00 each DVD (color, sound), dimensions variable. Collection Lannan Foundation; long-term loan to Dia Art Foundation, New York. Courtesy Sperone Westwater, New York. © 2010 Bruce Nauman/Artists Rights Society (ARS), New York.

is because within the phenomenon signaled by the singular noun "television" there are secreted three different operations: production, transmission (broadcast), and reception. If television means seeing at a distance, it can also be said that it transports vision itself, placing it directly before the viewer. But no single body could perceive this vision since it takes place, Weber argues, in three different places at once: the place of recording, the place of reception, and the place of transmission. Thus to watch television is to watch the invisible separation of the visual datum, split between its three places of habitation; and what the television screen does is to take this invisible separation and turn it into the singular, visual logo of a gestalt. Weber's conclusion is that television has to be characterized through the term "differential specificity," which, though it sounds like a paradox,[15] is necessary in order to respect the complexity of this form.

Mapping the Studio continues Nauman's investigations of video as a form of monitoring. The seven cameras within his studio were mounted to record continuously the invasion of the space by a horde of mice itself attacked from time to time by Nauman's cat. The mice, a shade of gray matching the concrete floor exactly, seem to explode into our field of vision only through their motion, like little furry blurs within the darkness. Barely visible, they are the support for a vision which is itself split between its site of recording and its site of reception. The projection screen—as Weber had seen it—is precisely the field on which this invisible separation surfaces as gestalt.

Mapping the Studio brings us into contact with Jameson's notion of television's specificity as well as those of Cavell and Weber. For as we ourselves patiently watch for the appearance of the mice, we transform ourselves into so many cats poised like Disney's Tom waiting for the appearance of little Jerry. Memories of Saturday afternoon cartoons flood us with bursts of narrativity in the Jamesonian sense of postmodern citation. And this brings us to yet another issue of specificity, namely the type of perception that reenacts the bodiless form of vision of the unmanned camera mindlessly watching its portion of the terrain. As we now watch our own portion, focused on this or that patch of wall, we feel ourselves embodying the recording device, thus splitting our own perceptual field into a having-been-there of past-time recording and a being-there-now of present reception. Nauman's video corridors avoided this differential perception by staging both the simultaneity of recording and reception and the synonymy of watcher and watched, as the

participant monitors himself moving down the corridor toward a view of his own body growing steadily smaller.

To become the subject of surveillance as one experiences *Mapping the Studio* is to reverse the conditions Michel Foucault outlines in *Discipline and Punish*, where the panopticon's structure produces the disciplinary subject through a constant surveillance in which the warden in the watchtower remains invisible, thus forcing the watched subject to internalize the surveillant authority and to become his or her own watcher: the obedient schoolfellow or the regimented soldier. The only experience we can have as the object of this gaze is when, sitting on our rolling desk chairs and scooting through the space like so many mice, we become the doubles of the little furry schmoos suddenly erupting into vision on the screens.

Fastidious in his use of language, Nauman's subtitle for this work, "Fat Chance John Cage," demands consideration. I decide it is an elegant reference to the masterpiece of the master of the modernist notion of the poetic medium: Stéphane Mallarmé's *A Roll of the Dice Will Never Abolish Chance*. If John Cage was the great apostle of chance as a form of composing that voided every possibility of reflection on the medium—making all sound, ambient as well as recorded, into music—Mallarmé held onto the magical specificity of poetic language, particularly its placement on the pages of a book, black against white, disappearing and reappearing as it crosses the gutter of the book's binding. By signaling chance, Nauman's subtitle focuses on the disembodiment of the gaze and its reembodiment by the work's viewers. Thus it names, I would argue, its own commitment to the specificity of video, even if that were Weber's paradoxical concept of self-difference. Even if the seven projectors and their surrounding walls appear to stage *Mapping the Studio* as the currently ubiquitous installation art, it seems to me that the work disdains this fashion.

If this is so, Nauman must be added to the little group of knights working in the service of the medium, from his earliest video corridors to his works such as *World Peace* and finally to *Mapping the Studio*. "Fat Chance," indeed, John Cage.

Words — *The unbearable lightness of architecture*

January 23, 2004—The *New York Times* publishes a color photo of Santiago Calatrava's subway entrance to the PATH trains, hovering next to Ground Zero like the dove that alighted on Noah's ark on the fortieth day. Intending the fragile web of steel as pure poetry, Calatrava is unconscious (or defiant) of its total kitsch.

The horror of kitsch has faded from contemporary experience. This is clear from the success of Daniel Libeskind as architect of the Ground Zero reconstruction. Libeskind is the master of dissimulation, cannily substituting language for tectonics in an outpouring of consolatory rhetoric that masks the reality of both site and structure. Example: In a competition to urbanize Sachsenhausen, the former concentration camp at Oranienburg (40 kilometers from Berlin), Libeskind decided to challenge the topography of the site with a new channel of water that would rhetorically purify the polluted earth. This giant canal he called the "Hope Incision," describing it as "a new way of dealing ecologically with the land."[16] Since his proposal did not provide for the 10,000 units of housing called for by the official program, Libeskind's project was disqualified; but due to its immediate appeal to the citizens of Oranienburg, pressure was applied to its mayor to invite Libeskind into discussion with the building committee to requalify his ideas.

The lesson to be learned from this was not lost on Libeskind. The layperson does not understand or care about the curtain walls or cantilevers of modern architecture as a medium of weight and support. He cares about "hope," "consolation," and "despair." The need for cleared land to exploit for commercial gain is so great that any tract, no matter how polluted, becomes valuable enough to sustain "ecological" renewal at monumental scale. If thousands of yuppies will be happy to live in a development on the shores of the "Hope Incision," despite the fact that below it is the site of the first active crematorium in Germany, the lesson is obvious. No matter how toxic the pollution, language will make it pure.

Libeskind's winning project for Ground Zero carries this lesson to the desolate crater in lower Manhattan. Of course there is a Freedom Tower, and, like the dolmens at Stonehenge, the ravaged pit will be striped once a year by the Wedge of Light, described by Mr. Libeskind as "a grand public open

124

space designed to illuminate the site at 8:40 a.m. when the first plane struck, and 10:28, when the second tower fell." Mr. Libeskind has nothing but praise for the birdlike PATH terminal: "axially positioned along the wedge—allowing light to penetrate through its open roof to the platform and tracks below. The idea has been brilliantly embraced and articulated."

AXial — *The aneurysm of lightness*

No one thinks about how kitsch such rhetoric is or how unbearably light this makes the tragic space of the terrorism of 9/11, as the cheerful declaration works to submerge it in the "shit" of fake emotions and disingenuous consolation. Kitsch is, it seems, a faded notion, wholly disarmed by the sentimentality of our present culture. It is an idea that has been washed away in its own violent rupture of the tracks of memory that would make a joke of a Freedom Tower (subtly crafted to mime the Statue of Liberty) or a Wedge of Light, or for that matter a subway station fashioned like an alighting bird.

The bathos of most installation art is unacceptable in just this way. Bill Viola is fond of submerging the televised human image under volumes of water, so that the galleries in which they are seen are bathed in the blue glow of the cathode ray tube. The consolatory aura of transubstantiation hovers over the figures of death.

The imaginable museum

André Malraux's *Museum without Walls (Le musée imaginaire)* praises the triumphs of photography as it transports faraway masterworks from their inaccessible locations (like the Cambodian temples of Angkor Wat) to the pages of the bourgeois art book. Georges Duthuit saw Malraux's happy encouragement for the stripping of archaeological sites as a form of imperialism. His stinging response was *le musée inimaginable*.

The off-the-wall museum

Malraux's museum without walls was the forerunner of postmodernism's cheerful pillage of historical art to disrupt the order of the specific medium, to wash it away, so to speak. If knights always end their move on a square of the opposite color, thereby leaping over installation, they also place whole sections of modernist art in a fork. These are the early twentieth-century transformations of museum galleries into the installation of sculptural incursions, like Duchamp's *Etant données*, Lissitzky's *Demonstration Room*, or Schwitters's *Merzbau*.

Throughout its history, modern art paradoxically turned to treating museum galleries as installations, or settings interpellated in the artist's own work. El Lissitzky transformed a Hannover museum gallery into an archive with his *Demonstration Room*: sliding screens with paintings hung on them that the visitor could pull out or push back at will (as the curator does in a museum's "dark storage").

Remembering the "three things," we see Duchamp constructing *Etant données* in the midst of the Philadelphia Museum of Art. A reprise of his *Large Glass* (*The Bride Stripped Bare by Her Bachelors, Even*), the work is a diorama with the naked bride spread-eagle on a mound of hay in the direct path of the viewer's sight as he peers through the two holes drilled through the rustic door that shields the spectacle from public view. At the same time transformed into a peeping Tom, the viewer is confirmed as a solitary spectator who can share his visual object with no one else. With a stroke, Duchamp's installation sweeps away centuries of wisdom about both the nature of the museum and that of art. In *The Critique of Judgment*, Immanuel Kant had given four conditions for the object to be judged "aesthetic" and hence a work of art. One of these is that the judgment "This is beautiful" must be spoken with "a universal voice," such that it applies to everyone and not just to *my* personal taste. It was the museum, born of the Enlightenment, that could enforce this "universal voice," making its objects simultaneously available to every visitor in its galleries and not just to Duchamp's solitary *voyeur*. It is needless to say that Duchamp is not a knight. His art utterly disperses the medium, invalidating it as the basis for any judgment at all.

126

Researching this book, I tried to find pictures of Documenta X's suite of installations for a reader not familiar with the genre. To my surprise nothing of the kind appeared either in the exhibition's catalog or in any other review of Documenta. I began to feel that Catherine David had suppressed such images, worried perhaps that still photographs could only betray the works. I remembered seeing the installations nightly on Arte's TV programs, and to resee them I went to INA at the Bibliothèque Nationale. INA is the Institut National d'Audiovisuel, the formidable national archive that has tapes of everything *ever* broadcast on the French media. This is where I saw "A la rencontre de l'art contemporain, Catherine David et la Documenta X," Arte's program broadcast on August 20, 1997. A forty-five-minute interview of Catherine David conducted on a train, the program both tracks her search for the exhibition's entries and develops her position on the white cube, as she joins her argument to Brian O'Doherty's. Is it unfair to follow Dickens by making her a character in this narrative? Hers is a public voice, which she lent to Arte's broadcast, and the directorship of Documenta is the most powerful platform the art establishment can bestow. As is clear, Documenta orchestrates the position its director espouses. Catherine David was a curator at the Jeu de Paume, the *Kunsthalle* of contemporary art in Paris, another highly visible post. She is likable, intelligent, articulate: a worthy adversary, I think.

The medium as expanded field

The aphorism that opens this book—"Brain — *The medium is the memory*"— specifically opposes Marshall McLuhan's aphorism "The medium is the message." McLuhan exults in the *non*-specificity of the medium, its "message" always referring to another, earlier medium. For the media theorist, then, the content of writing is speech, just as the written word is the content of print, and print is the content of the telegraph. "The medium is the memory" insists, instead, on the power of the medium to hold the efforts of the forebears of a specific genre in reserve for the present. Forgetting this reserve is the antagonist of memory, a forgetting encouraged by the three things. The paradigm of

the /medium/ could thus be mapped as *memory versus forgetting*. On structuralism's neutral axis, the combination of not-memory and not-forgetting would be installation. We have seen in installations such as Rebecca Horn's a persistence of what Jacques Lacan calls the letter, or preeminent signifier. In this sense, "letter" is the unconscious of a practice that cannot escape the specific memory of painting no matter how hard it tries, as Horn's *Book of Ashes* propels the monochrome into contemporary focus, unable to forget it.

To fill out the expanded field, there is kitsch as the combination of memory and its opposite (not-memory). In this position kitsch operates the way mass-produced substances (formica) fake the artisanal originals (wood carving) that they can only remember through the lightest of counterfeits. On the other side, the combination of forgetting and not-forgetting would be the technical support, where the need to forget exhausted mediums (like oil painting) nonetheless recalls *moments* in their histories—as when Ruscha's *Stains* thrust us into stain painting as a "tiger's leap" back to the historical memory of a medium he is working to forget.

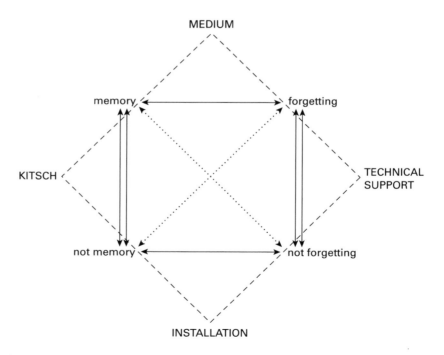

Under Blue Cup — *The aphorism of the stain*

At the outset, I promised to "disappear into this narrative's commitments to the art of the present." Nonetheless, I saw the medium as calling for an imbrication in memory to mirror the tradition that enables its automatism. "The medium is the memory" is the first aphoristic reminder, after which comes "The amnesia of the stain." The parallel between the attack on my own powers of recall and "the three things" that threaten the medium's memory provides a narrative that might provoke the reader's curiosity. It is not an idle curiosity, I think, but sinks into the aphoristic network of the book.

I am born

There are certain sentences in English impossible to utter. David Copperfield's "I am born" is one of them; a second is "I am dead."

"I am comatose" is clearly a third. The innate intelligence of the body reacts to a physical insult to the brain by putting it to sleep. Coma is the hibernation that relieves the brain of its duties, giving it time and strength to restore itself. While in coma, consciousness is like a swimmer moving, eel-like, just beneath the water of sentience.

Nurses in intensive care urge the families of comatose patients to stimulate their perceptions; to read and talk to them. Denis, my husband, brought one of my favorite books to my bedside and began to read *Our Mutual Friend*. An excellent performer of French prose, his pronunciation and phrasing in English are less certain. During the eighth chapter of Dickens's novel "unconscionable" arrives, a rock against the flow of sound, as the book's hero says to his future employer, "I am not so unconscionable as to think it likely that you would accept me on trust at first sight, and take me out of the very street." Denis describes his wonder at seeing me break the surface of coma, rising out of the water, an imperious dolphin, to correct his rendering of this word. "Un**con**scionable," I said.

This triumph of memory and language persisted in the next days, when my phone rang and I was greeted by François Rouan, a close friend. Because

he speaks not a word of English this conversation had to be in French, a feat I miraculously pulled off over the phone.

All things hang together

But language is not the same as spatial relations—the perceptual experience of gestalt that was to be tested a few days later by the occupational therapist assigned to me in hospital. My Julie (all my therapists were named Julie, so I took to calling them "my Julies") showed me a picture puzzle. At the level of a two-year-old, the puzzle disassembled the image of a jetty leading to a lighthouse with a sailboat beside it and a cloud and disk of sun above. Each shape was a brightly colored plane outlined in black. Cut into six sections, the picture would be scattered on my tray for me to reassemble. It was when I could not join one section to another, to reconstruct boat, jetty, or sky, that Denis's optimism failed him. This was an infantile level of spatial relations and it seemed I would never surpass it again.

I remember neither the Dickens nor the puzzle, the tedium of the hospital fusing my experiences together. The most I remember is the phone call and the nudity of my hospital room, stripped of every mirror. In *My Year Off*, Robert McCrum's account of his recovery from a stroke, he tells of being wheeled outside his hospital; "On the way out we passed a man with his head stitched like a second-hand football, the whole way round."[17] I guess the mirrors had been removed so that, my head having been shaved for my surgeries, I would be spared that sight. Friends urged me to keep a diary of my illness. But because I had no memory of any of its opening phases, the seizure at its onset, the surgeries, or my coma, a diary seemed out of reach.

The most I can summon is the network of the twenty-six aphorisms, cycling around the stain.

130

Notes

ONE

1. Jean-Luc Nancy, *The Muses*, trans. Peggy Kamuf (Stanford: Stanford University Press, 1994), p. 2.

2. In "Signature, Event, Context," Jacques Derrida argues that *iterability*—the repetition of any message structured by a code—makes irrelevant the presence of either sender or receiver in order to attach the sender's intended meaning (the *vouloir dire*) to the message. In Derrida, *Margins of Philosophy*, trans. Alan Bass (Chicago: University of Chicago Press, 1982).

3. Hubert Damisch's *L'amour m'expose* (Brussels: Yves Gevaert, 2000) takes this up explicitly (p. 21). The book is a retrospective account of his exhibition "Moves," held in the Museum Boijmans Van Beuningen in August 2000. In his chapter "The Bishop's Diagonal," he analyzes the bishop's move as "itself nonetheless off-axis, the bishop moving in the interstices between lines or columns and, so to speak, across their juncture. On the model of what, in perspectival construction, dictates the disposition of the parallel lines at the base of the chessboard pavement, the bishop's diagonal, like the knight's move, displays the convention basic to the game and its relative arbitrariness. And this is so, up to what in this move can be simultaneously destructive and constructive: all shifts of a piece on the chessboard correspond to a positional transformation, which, however limited and carefully calculated it might be, nonetheless participates in whatever degree of entropy the system tends to under the combined effect of the motion of the pieces and their progressive diminution over the progress of the game."

4. T. J. Clark, *The Sight of Death* (New Haven: Yale University Press, 2006), p. 5.

5. In his "Modernist Painting" (1960), Greenberg asserted: "It quickly emerged that the unique and proper area of competence of each art coincided with all that was unique to the nature of its medium. The task of self-criticism became to eliminate from the effects of each art any and every effect that might conceivably be borrowed from or by the medium of every other art." In Clement Greenberg, *The Collected Essays and Criticism*, ed. John O'Brian, vol. 4 (Chicago: University of Chicago Press, 1993), p. 86.

6. Stanley Cavell, *The World Viewed* (Cambridge: Harvard University Press, 1979), p. 104.

7. Ibid., pp. 101ff. "I characterized the task of the modern artist," he writes, "as one of creating not a new instance of his art but a new medium in it. One might think of this as the task of establishing a new automatism" (p. 104).

8. Michael Fried in Hal Foster, ed., *Discussions in Contemporary Culture*, no. 1 (Seattle: Bay Press, 1987), p. 73.

9. Michael Fried, *Art and Objecthood* (Chicago: University of Chicago Press, 1998), p. 41.

10. Michel Foucault, *The Archaeology of Knowledge*, trans. A. M. Sheridan Smith (New York: Pantheon Books, 1972), p. 127.

11. Michel Foucault, *The Order of Things: An Archaeology of the Human Sciences* (New York: Pantheon Books, 1971), p. 218, where he writes, "the link between one organic structure and another . . . must be the identity of the relation between the elements." (See his chapter 8, "Labour, Life, Language.")

12. See Hayden White, "Foucault Decoded," in White, *Tropics of Discourse* (Baltimore: Johns Hopkins University Press, 1978), p. 254, for a discussion of Foucault's relation to Vico for the structure of *The Order of Things*.

13. Cavell, *The World Viewed*, p. 107.

14. Roland Barthes, *The Neutral*, trans. Rosalind E. Krauss and Denis Hollier (New York: Columbia University Press, 2005), p. 42.

15. The expanded field is developed in my *The Originality of the Avant-Garde and Other Modernist Myths* (Cambridge: MIT Press, 1985). The binary of memory versus forgetting is developed below in the section "The Medium as Expanded Field" in chapter three.

16. The informed reader will recognize allusions here to works by Chris Burden, Robert Smithson, Richard Long, and Walter De Maria.

17. Readers will recognize the postmodernists referred to here as Anselm Kiefer, Sandro Chia, and Enzo Cuchi.

18. Cavell, *The World Viewed*, p. 105.

19. Roland Barthes, *Camera Lucida*, trans. Richard Howard (New York: Hill and Wang, 1981), p. 3.

20. Ibid., 117.

21. Jacques Derrida, *Speech and Phenomena*, trans. David Allison (Evanston: Northwestern University Press, 1973), p. 59.

22. Ibid., p. 6.

23. Ibid., pp. 59, 58.

24. In Carolyn Christov-Bakargiev, *William Kentridge* (Brussels: Palais des Beaux-Arts, 1998), p. 75.

25. See Thierry de Duve, *Kant after Duchamp* (Cambridge: MIT Press, 1996), p. 333.

26. Ibid., p. 245.

27. It is, as Thierry de Duve puts it, "as though this essence were not specific but generic" (ibid., p. 152). Here we might remember Jean-Luc Nancy's question "Why are there several muses and not just one?"

28. De Duve, *Kant after Duchamp*, p. 152.

notes

29. Maurice Merleau-Ponty, *The Phenomenology of Perception*, trans. Colin Smith (London: Routledge and Kegan Paul, 1962), p. 68.

30. Marshall McLuhan, *Understanding Media: The Extensions of Man* (New York: Signet Books, 1964), and *The Gutenberg Galaxy* (Toronto: University of Toronto Press, 1962); and Friedrich Kittler, *Gramophone, Film, Typewriter*, trans. Geoffrey Winthrop-Young and Michael Wutz (Stanford: Stanford University Press, 1999).

31. Kittler, *Gramophone, Film, Typewriter*, p. 2.

32. Walter Benjamin, "The Work of Art in the Age of Mechanical Reproduction," in Benjamin, *Illuminations*, trans. Harry Zohn (New York: Schocken Books, 1969), p. 222. See Kittler, *Gramophone, Film, Typewriter*, p. 3.

33. Benjamin, "The Work of Art in the Age of Mechanical Reproduction," p. 223.

34. Kittler, *Gramophone, Film, Typewriter*, pp. 3, 200.

35. Benjamin, "The Work of Art in the Age of Mechanical Reproduction," p. 237.

36. Geoffrey Winthrop-Young and Michael Wutz, "Translators' Introduction," in Kittler, *Gramophone, Film, Typewriter*, p. xxxv.

37. Fredric Jameson, *The Political Unconcious* (Ithaca: Cornell University Press, 1981), p. 154.

38. See Winthrop-Young and Wutz, "Translators' Introduction," p. xxxvi.

39. In Sam Weber's analysis of the "constitutive heterogeneity" of television, he discusses the newly wrought forms of perception, reception, and transmission, the latter two the effect of the fact that television is broadcast. Samuel Weber, "Television: Set and Screen," in Weber, *Mass Mediauras: Form, Technics, Media* (Stanford: Stanford University Press, 1996), pp. 109–110.

40. Merleau-Ponty, *The Phenomenology of Perception*, p. 68.

41. Roland Barthes, *Writing Degree Zero*, trans. Annette Lavers (New York: Hill and Wang, 1968), p. 16.

42. See Emile Benveniste, "The Correlation of Tense in the French Verb," in Benveniste, *Problems in General Linguistics*, trans. Mary Elizabeth Meek (Coral Gables: University of Miami Press, 1971), pp. 205–222.

43. Barthes, *Writing Degree Zero*, p. 16.

44. Barthes, *The Neutral*, p. 54.

45. Raymond Queneau, *The Bark Tree*, trans. Barbara Wright (London: Calder and Boyars, 1968), p. 244.

46. In *Camera Lucida*, Barthes calls this Tathata. See my "Notes on the Index," in *The Originality of the Avant-Garde*.

47. Barthes, *Camera Lucida*, p. 15.

48. Barthes, *Writing Degree Zero*, pp. 14–15.

49. *Mallarmé*, trans. Wallace Fowlie (Chicago: University of Chicago Press, 1954), p. 227. For the original, see Stéphane Mallarmé, *Oeuvres complètes* (Paris: La Pléiade, Editions Gallimard, 1945), p. 27.

50. Roland Barthes, *The Pleasure of the Text*, trans. Richard Miller (New York: Hill and Wang, 1975), pp. 14–15.

51. Ibid.

52. Ibid., p. 12.

TWO

1. From "A la rencontre de l'art contemporaine, Catherine David et la Documenta X," television program, Arte, broadcast August 20, 1997.

2. Brian O'Doherty, *Inside the White Cube: The Ideology of the Gallery Space* (Berkeley: University of California Press, 1999). This is a collection of four essays published between 1976 and 1981: "Inside the White Cube: Notes on the Gallery Space," *Artforum* 14 (March 1976); "Inside the White Cube: The Eye and the Spectator," *Artforum* 14 (April 1976); "Inside the White Cube: Context as Content," *Artforum* 15 (November 1976); "The Gallery as Gesture," *Artforum* 20 (1981).

3. O'Doherty, "Inside the White Cube: Notes on the Gallery Space"; O'Doherty, "Inside the White Cube: Context as Content," p. 44.

4. See Ann Reynolds, *Robert Smithson: Learning from New Jersey and Elsewhere* (Cambridge: MIT Press, 2003).

5. O'Doherty, "Inside the White Cube: Context as Content," p. 44.

6. Brian O'Doherty, *Studio and Cube: On the Relationship between Where Art Is Made and Where Art Is Displayed* (New York: Buell Center/FORUM Project, 2007), p. 10.

7. Charles Dickens, *Bleak House* (Oxford: Oxford University Press, 1998), p. 282.

8. Roland Barthes, *The Pleasure of the Text*, trans. Richard Miller (New York: Hill and Wang, 1975), pp. 15, 17.

9. Susan Sontag, *Against Interpretation* (New York: Farrar, Straus and Giroux, 1961), p. 14.

10. See Helen Molesworth, "The Anyspacewhatever," *Artforum* 47 (March 2009), p. 102; Nicolas Bourriaud, *Relational Aesthetics*, trans. Simon Pleasance and Fronz Woods (Dijon: Les Presses du Réel, 2002).

11. Nicolas Bourriaud, interviewed by Bennett Simpson, *Artforum* 39 (April 2001), p. 48.

12. Bourriaud, *Relational Aesthetics*, pp. 13, 17–18.

13. Ibid., p. 7.

14. Barthes, *The Pleasure of the Text*, p. 10.

15. Milan Kundera, *The Unbearable Lightness of Being*, trans. Michael Henry Heim (New York: Harper-Collins, 1991), p. 244.

16. Stanley Cavell, *Must We Mean What We Say?* (New York: Charles Scribner's Sons, 1969), pp. 205–206, 229.

17. Ibid., pp. 188–189.

18. Jack Kerouac, *On the Road* (New York: Penguin Books, 1957), p. 235.

19. Ed Ruscha, *Leave Any Information at the Signal: Writings, Interviews, Bits, Pages*, ed. Alexandra Schwartz (Cambridge: MIT Press, 2002), p. 313; in following paragraphs, this source is cited parenthetically in the text.

20. Carolyn Christov-Bakargiev, *William Kentridge* (Brussels: Palais des Beaux-Arts, 1998), p. 112.

21. Cavell, *Must We Mean What We Say?*, p. 200.

22. Stanley Cavell, *The World Viewed* (Cambridge: Harvard University Press, 1979), p. 104.

23. Roland Barthes, "The Third Meaning," in Barthes, *Image, Music, Text*, trans. Stephen Heath (New York: Hill and Wang, 1977), p. 67.

24. In his *théorie du /nuage/* (Paris: Editions du Seuil, 1972), Hubert Damisch develops the paradoxical importance of the cloud, with its atmospheric resistance to the strict geometry of Renaissance painting, for the integration of perspective as a system.

25. P. Adams Sitney, *Visionary Film: The American Avant-Garde* (New York: Oxford University Press, 1974).

26. Hal Foster in "The Un/making of Sculpture" writes, "[Serra] was also critical of minimalism, not only of its closed system of construction but of its odd preoccupation with painting. Although the minimalist object is often misnamed 'sculpture,' it developed primarily out of hard-edge painting (as the early career of Judd alone testifies). For Serra, precisely because its unitary forms and serial orderings sought to defeat pictorial conventions of relational composition, they remained too bound by these concerns. Like his peers, he wanted to defeat this pictoriality, especially as it underwrote Gestalt readings of art, which he saw as idealist totalizations that serve to conceal the construction of the work and to suppress the body of the viewer." In Foster, ed., *Richard Serra* (Cambridge: MIT Press, 2000), p. 177.

27. Walter Benjamin, "Theses on the Philosophy of History," in Benjamin, *Illuminations*, trans. Harry Zohn (New York: Schocken Books, 1969), p. 261.

28. Apart from Manolo Borja, MACBA's director, my collaborators in this project were Benjamin Buchloh and Catherine de Zegher.

29. See Seamus Deane, "Critical Reflections," *Artforum* 32 (December 1993).

30. In his essay on Coleman, "Reanimations," George Baker sees Coleman's early films through the critical lens of the *informe* (*October* 104 [Spring 2003], p. 41).

31. Michael Newman, "Allegories of the Subject: The Theme of Identity in the Work of James Coleman," in *James Coleman: Selected Works* (Chicago: Renaissance Society; London: Institute of Contemporary Arts, 1985), p. 26.

32. Christov-Bakargiev, *William Kentridge*, p. 68; in following paragraphs, this source is cited parenthetically in the text.

33. Cavell, *The World Viewed*, p. 105.

THREE

1. Viktor Shklovsky, *Knight's Move*, trans. Richard Sheldon (London: Dalkey Archive Press, 2005), p. 3.

2. In "Art as Technique" Shklovsky calls this laying bare "defamiliarization," which succeeds in removing objects from the automatism of perception. Plot construction is another device that can be laid bare by roughened form and retardation. In *Russian Formalist Criticism: Four Essays*, trans. Lee T. Lemon and Marion J. Reis (Lincoln: University of Nebraska Press, 1965), pp. 13, 23.

3. Viktor Shklovsky, "Sterne's Tristram Shandy," in *Russian Formalist Criticism*, p. 30.

4. See Hubert Damisch, *The Origin of Perspective*, trans. John Goodman (Cambridge: MIT Press, 1994).

5. Gertrude Stein, *Everybody's Autobiography* (Cambridge: Exact Change, 1993), p. 86.

6. See Jacques Lacan, "The Agency of the Letter in the Unconscious or Reason since Freud," in Lacan, *Écrits*, trans. Alan Sheridan (New York: Norton, 1977), p. 167. The "defiles of the signifier" appear in Lacan, *The Four Fundamental Concepts of Psycho-Analysis*, ed. Jacques-Alain Miller, trans. Alan Sheridan (New York: Norton, 1978), chapter 12, pp. 149–160.

7. Jacques Lacan, "The Purloined Letter," in *The Seminar of Jacques Lacan: Book II*, ed. Jacques-Alain Miller, trans. Sylvana Tomaselli (New York: Norton, 1988), p. 202: "in order to be in the same position vis-à vis the letter as the Queen was, in an essentially feminine position, the minister falls prey to the same trick as she did."

8. Jacques Lacan, "Seminar on 'The Purloined Letter,'" in *Écrits: The First Complete Edition in English*, trans. Bruce Fink in collaboration with Héloïse Fink and Russell Grigg (New York: Norton, 2006), pp. 24–25.

9. Denis Hollier, "Surrealist Precipitates," *October* 69 (Summer 1994).

10. See *HF/RG: Harun Farocki, Rodney Graham* (Paris: Jeu de Paume, 2009); Harun Farocki, *One Image Doesn't Take the Place of the Previous One* (Montreal: Leonard & Bina Ellen Art Gallery, Concordia University, 2008); Alice Malinge, "Harun Farocki, autoportrait d'une pratique," master's thesis (University of Rennes, September 2008); Christa Blümlinger, *Harun Farocki: Reconnaître & poursuivre* (Paris: Théâtre Typographique, 2002).

11. In her master's thesis, Alice Malinge devotes a chapter to comparing the objectivization of Farocki's work to the alienation effect practiced by Bertolt Brecht. Wanting to uncover what she calls "the conditions of possibility of critical reading," she lists Farocki's procedures to produce this effect as: episodic stories, frequent interruptions by voice-off or inserts, an unnatural game, a separation of sound and image, a stripped-down setting, the quotation of diverse sources, and finally a didactic stance (Malinge, "Harun Farocki," pp. 29–30). Farocki undertakes a study that can be related to the anti-illusionist procedure of Brecht, which is to confront the "visual" (by images of military or civil surveillance, advertisements, propaganda films) with the possibilities of the "image" as understood by Serge Daney: "The visual is without angle/reverse angle; nothing is lacking to it, it is closed in, in a loop, a little like the pornographic spectacle image, which is only the ecstatic verification of the functioning of the organs and of itself. . . . The image is always more or less than itself." Serge Daney, "Après tout," in *La politique des auteurs* (Paris: Cahiers du Cinéma, 1984).

12. Fredric Jámeson, *Postmodernism, or, The Cultural Logic of Late Capitalism* (Durham: Duke University Press, 1991), p. 70.

13. Stanley Cavell, "The Fact of Television," in John Hanhardt, *Video Culture* (New York: Visual Studies Workshop, 1986), p. 212.

14. Samuel Weber, "Television: Set and Screen," in Weber, *Mass Mediauras: Form, Technics, Media* (Stanford: Stanford University Press, 1996), p. 110.

15. The paradox can be read off of the Derridean *différance*, meant to deconstruct the very possibility of "specificity" of the constancy of the "self" by showing it always-already divided and thus self-differing.

16. Daniel Libeskind, 1995 Raoul Wallenberg Lecture, University of Michigan. The following quotations are from the same source.

17. Robert McCrum, *My Year Off* (New York: Norton, 1988), p. 102.

Index

Page numbers in boldface indicate illustrations.

140

141

index

UNDER BLUE CUP

Rosalind E. Krauss

In *Under Blue Cup*, Rosalind Krauss explores the relation of aesthetic mediums to memory—her own memory having been severely tested by a ruptured aneurysm that temporarily washed away much of her short-term memory. (The title *Under Blue Cup* comes from the legend on a flash card she used as a mnemonic tool during cognitive therapy.) Krauss emphasizes the medium as a form of remembering; contemporary artists in what she terms the "post-medium condition" reject that scaffolding. Krauss explains the historical emergence of the post-medium condition and describes alternatives to its aesthetic meaninglessness, examining works by "knights of the medium"—contemporary artists who extend the life of the specific medium.

These artists—including Ed Ruscha, William Kentridge, Sophie Calle, Harun Farocki, Christian Marclay, and James Coleman—reinstate the recursive rules of a modernist medium by inventing what Krauss terms new technical supports, battling the aesthetic meaninglessness of the post-medium condition. The "technical support" is an underlying ground for aesthetic practice that supports the work of art, as canvas supported oil paint. The technical support for Ruscha's fascination with gas stations and parking lots is the automobile; for Kentridge, a similar support is the animated film; for Calle, photojournalism; for Coleman, a modification of PowerPoint; for Marclay, synchronous sound. Their work, Krauss argues, recuperates more than a century of modernist practice.

The work of the post-medium condition—conceptual art, installation, and relational aesthetics—advances the idea that the "white cube" of the museum or gallery wall is over. Against this, Krauss argues that the technical support extends the life of the white cube, restoring autonomy and specificity to the work of art.

Rosalind E. Krauss, editor and cofounder of *October* magazine, is University Professor at Columbia University. She is the author of *The Originality of the Avant-Garde and Other Modernist Myths*, *The Optical Unconscious*, *The Picasso Papers*, *Bachelors*, and *Perpetual Inventory*, all published by the MIT Press.

Cover image: William Kentridge, drawing from *Weighing . . . and Wanting*, 1998. Courtesy of the artist and Marian Goodman Gallery, New York/Paris.